COOL SPOTS
MIAMI / SOUTH BEACH

teNeues

Imprint

Editor: Patrice Farameh

Editorial coordination: Michelle Galindo, Anne Dörte Schmidt

Photos : Seth Browarnik/Red Eye Productions (Opium Garden, 68), courtesy Ritz Carlton South Beach (Ritz Carlton South Beach, Cover, 80), courtesy André Balazs Properties (The Raleigh Hotel) All other photos are by Roland Bauer, Katharina Feuer, Michelle Galindo, Martin Nicholas Kunz

Introduction: Patrice Farameh

Layout & Pre-press: Martin Nicholas Kunz, Anne Dörte Schmidt

Imaging: Jan Hausberg

Translations: CET Central European Translations GmbH
Stefan Scheuermann (Spanish), Stefanie Guim Marcé (German), Virginie Delavarinya-Ségard (French), Fjona Stühler (Italian)

Produced by fusion publishing GmbH, Stuttgart . Los Angeles www.fusion-publishing.com

Published by teNeues Publishing Group

teNeues Verlag GmbH + Co. KG
International Sales Division
Speditionstr. 17
40211 Düsseldorf, Germany
Tel.: 0049-(0)211-994597-0
Fax: 0049-(0)211-994597-40
E-mail: books@teneues.de

teNeues Publishing Company
16 West 22nd Street
New York, NY 10010, USA
Tel.: 001-212-627-9090
Fax: 001-212-627-9511

teNeues Publishing UK Ltd.
P.O. Box 402
West Byfleet, KT14 7ZF
Great Britain
Tel.: 0044-1932-403509
Fax: 0044-1932-403514

teNeues France S.A.R.L.
4, rue de Valence
75005 Paris, France
Tel.: 0033-1-55766205
Fax: 0033-1-55766419

teNeues Ibérica S.L.
C/Velazquez 57 6 Izd
28001 Madrid, Spain
Tel./Fax: 0034-6 57 13 21 33

teNeues Italia
Representative Office
Via San Vittore 36/1
20123 Milano, Italy
Tel.: 0039-347-7640551

Press department: arehn@teneues.de
Phone: 0049-2152-916-202

www.teneues.com

ISBN-10: 3-8327-9153-1
ISBN-13: 978-3-8327-9153-7

© 2006 teNeues Verlag GmbH + Co. KG, Kempen

Printed in Italy

Bibliographic information published by Die Deutsche Bibliothek.
Die Deutsche Bibliothek lists this publication in the Deutsche Nationalbibliografie;
detailed bibliographic data is available in the Internet at http://dnb.ddb.de.

Contents Page

Introduction 5

Bal Harbour Shops 10
Casa Casuarina 12
Casa Tua 18
Clinton South Beach 22
Hotel Astor 26
Hotel Victor 28
Johnny V 34
Lincoln Road 38
Mandarin Oriental Miami 44
Mlami Design District 48
Mynt Lounge 54
Nikki Beach 58
Nobu 62
Ocean Drive 64
Opium Garden 68
Pearl 72
Prime 112 74
Privé 76
Ritz Carlton South Beach 78
Rok Miami 84
Snatch 86
Spire Bar & Lounge 88
Suite Lounge Miami Club 90
Tantra 94
The Forge 96
The Hotel of South Beach 98
The Raleigh Hotel 102
The Setai 106
The Standard Miami 112
Townhouse 118
Vue 124
VIX 126
Wish 130

Map 134

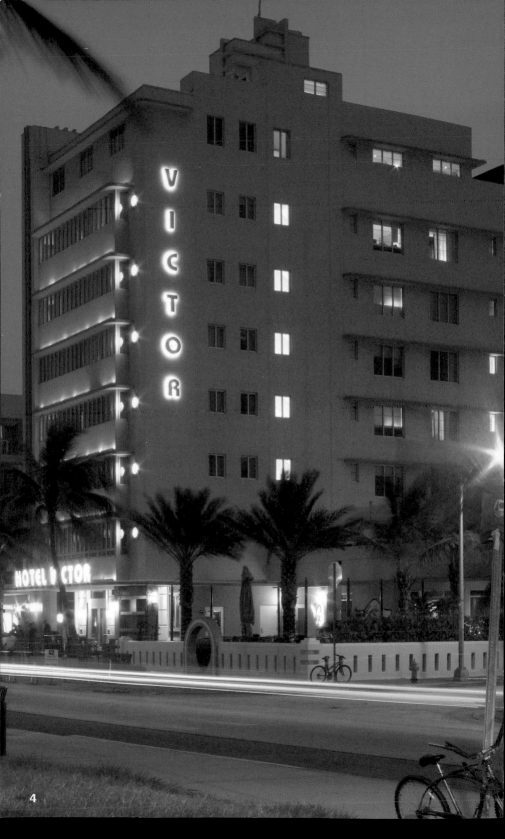

Introduction

They say one shouldn't judge a book by its cover, and nothing in Miami is ever what it seems. First and last impressions are constantly changing. Full of stunningly beautiful people and places, Miami is a sub-tropical paradise washed by brilliant southern light, kissed by enveloping blue-green, shimmering seas that gently roll to a white sand shore. Miami's zest for all things sensual is showcased in its music and food: spirited salsa and cool jazz, a cuisine that unites fresh seafood with tropical flavors, all providing evidence of a city dedicated to the spices of life. The sultry, seductive Miami entertains many identities: quiet haven, retiree refuge, celebrity playground, cutting-edge jet-setting wonderland, and tourist Mecca. And that's just an understated example of the dreamlike, Felliniesque world that exists here at the farthest tip of the country.
South Beach, one of the most famous neighborhoods in the world, is a 24-hour-a-day playground where the ultra rich and famous cavort around Ocean Drive in sidewalk cafes and world-class restaurants. The kitschy, candy-coated Art Deco District, home to 400 registered historic buildings, have oceanfront streets lined with lovely boutique hotels and celebrity-soaked bars.
Within this continental Caribbean city, few spots hold the glamour, history, and appeal of Miami. Once a retreat for fashion industry executives and an ideal location for photo shoots with supermodels and famous photographers, South Beach became the place to see and be seen. These initial roles ultimately led to today's Miami, the capital of recreation and self-assertive flamboyance. Chic restaurants and ultra-lounges started appearing in hotel lobbies, and a new cool place to mix and mingle developed.
South Beach is America's celebrity-saturated Riviera, with a touch of St. Tropez, but the French Riviera has never had a beach as beautiful, or a nightlife so diverse. South Beach is like Cannes run by trendsetters, where everyone's invited and no jacket is required. It's a place where red Ferraris make complete sense. It's where you can become someone else.

<div align="right">Patrice Farameh</div>

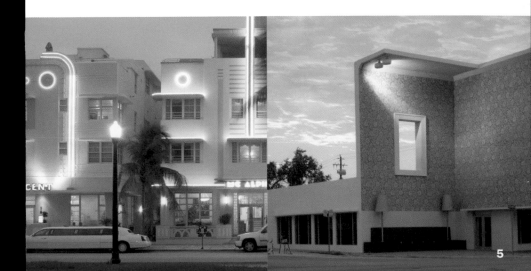

Introducción

Los libros no se valoran por la cubierta, así que no sorprende que en Miami nada sea lo que parece. A menudo engañan la primera y la última impresión. Miami, llena de gentes y lugares increíblemente estupendos, es un paraíso subtropical bañado por la brillante luz del Sur y el azul verdoso del centelleante mar, que suavemente acaricia las playas de arena blanca. La pasión que en Miami despierta cualquier detalle sensual, se refleja en la música y en la cocina, entre salsa caliente y jazz fresco, que mezcla los pescados y mariscos con un sabor tropical. Todo es el vivo reflejo de a una ciudad plenamente entregada a las especias de la vida. El morbo seductor de Miami tiene múltiples facetas. Es un puerto tranquilo, un refugio para los jubilados, un patio de recreo para las celebridades, el país de las maravillas de la jet más sofisticada y una Meca para los turistas. Y se podrían añadir otras muchas facetas para hacer justicia a este mundo de ensueño felliniano que aquí, en la punta más recóndita del país, se ha hecho realidad.

South Beach, uno de los barrios más famosos del planeta, es durante veinticuatro horas al día el patio de recreo de los mega-ricos y famosos que pululan alrededor del Ocean Drive y pueblan las terrazas y restaurantes de categoría mundial. En el Distrito Art Deco, con su edulcorada exquisitez kitsch, se hallan 400 edificios catalogados como patrimonio histórico y en las avenidas que bordean el litoral se suceden magníficos hoteles boutique y bares alborotados por celebridades.

En esta ciudad del caribe continental, pocos lugares conservan el glamour, la historia y la atracción de Miami. En su tiempo fue un lugar de descanso para los altos ejecutivos de la industria de la moda y el sitio ideal para realizar sesiones fotográficas con supermodelos y fotógrafos famosos. Hoy en día, South Beach se ha convertido en el lugar que hay que ver y donde hay que ser visto. En última instancia, desde que en sus inicios le asignaron aquel papel, el destino de la ciudad no ha podido ser otro que convertirse en esta gran capital del ocio y de la extravagancia exuberante. Los restaurantes de diseño y las ultra-lounges que empezaron a proliferar en los hoteles constituyen hoy un nuevo marco para el intercambio y la vida en sociedad.

South Beach, saturada de celebridades, es la Riviera de America y posee cierto aire de Saint Tropez. Pero la Riviera francesa nunca ha tenido una playa tan hermosa ni una vida nocturna tan divertida. South Beach es algo como Cannes puesta en manos vanguardistas, todo el mundo está invitado y no se requiere corbata. Es un lugar en el que conducir un Ferrari rojo no desentona con el ambiente, en el que puedes convertirte en otra persona.

Patrice Farameh

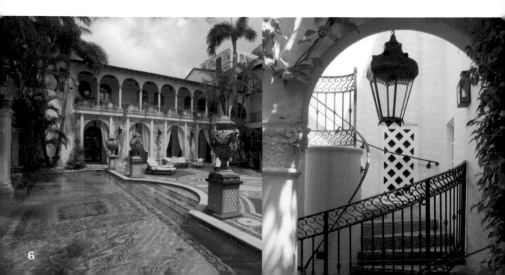

Einleitung

So wie man ein Buch nicht allein nach seinem Umschlag beurteilen soll, ist auch in Miami nichts wie es scheint. Die Eindrücke ändern sich ständig. Miami ist mit seinen vielen tollen Menschen und Orten ein subtropisches Paradies, das vom strahlenden Licht des Südens eingehüllt und von blaugrün schimmernden Meeren umgeben ist, die an den weißen Sandstrand schwappen. Miamis Lust auf alles Sinnliche zeigt sich in der Musik und im Essen: temperamentvolle Salsa und cooler Jazz, eine Küche, die frische Fische und Meeresfrüchte mit tropischen Aromen kombiniert. All dies zeigt eine Stadt, die sich ganz der Würze des Lebens hingibt. Das sinnliche, verführerische Miami hat viele Gesichter: ruhiger Hafen, Rentnerparadies, Spielwiese der Promis, angesagtes Jetset-Wunderland und Touristenmekka. Und das ist nur ein untertriebenes Beispiel der Traumwelt à la Fellini, die hier am äußersten Zipfel des Landes existiert.

South Beach, eine der berühmtesten Wohngegenden der Welt, ist eine an 24 Stunden am Tag geöffnete Spielwiese, auf der sich die Superreichen und Berühmten am Ocean Drive in Straßencafés und Weltklasserestaurants tummeln. Die Uferstraßen dieses kitschigen, zuckersüßen Art-Déco-Distrikts mit seinen 400 denkmalgeschützten Gebäuden sind gespickt mit reizenden Boutiquehotels und Promi-Bars.

In dieser karibischen Stadt auf dem Kontinent zeigen wenige Orte den Glamour, die Geschichte und den Reiz Miamis. South Beach, einst ein Hort der Führungsetagen der Modebranche und eine ideale Location für Fotoshootings mit Supermodels und berühmten Fotografen, ist zu einem Ort geworden, an dem man sieht und gesehen wird. Diese ursprünglichen Funktionen haben zum heutigen Miami als Hauptstadt der Freizeit und selbstbewussten Extravaganz geführt. Schicke Restaurants und Lounges entstanden in den Hotellobbys, und es entwickelten sich neue, coole Treffpunkte.

South Beach ist Amerikas Promi-Riviera mit einem Hauch St. Tropez. Allerdings hatte die französische Riviera niemals einen so schönen Strand und ein abwechslungsreiches Nachtleben. South Beach ist wie ein von Trendsettern geführtes Cannes, wo alle eingeladen sind und keine Smokingpflicht herrscht. Ein Ort, an dem rote Ferraris voll und ganz Sinn machen. Ein Ort, an dem man zu jemand anderem wird.

Patrice Farameh

Introduction

On dit que l'habit ne fait pas le moine, et Miami le confirme. La première et dernière impression change constamment. Regorgeant de personnes et de lieux d'une beauté renversante, Miami est un paradis subtropical à l'éclat méridional, embrassé de mers miroitantes bleu-vert qui se déroulent doucement sur une plage de sable blanc. L'élan Miami pour la sensualité transparaît dans sa musique et dans sa gastronomie : salsa pleine d'allant et jazz cool, cuisine qui marie les produits de la mer frais aux saveurs tropicales, attestant d'une ville pleine de piquant. Miami, sensuelle et séduisante, décline de nombreuses identités : havre de paix, refuge des retraités, lieu de prédilection des célébrités, pays merveilleux jet-set d'avant-garde et Mecque des touristes. Et ce n'est qu'un exemple discret de l'univers felliniesque onirique qui règne ici à l'extrémité la plus éloignée du pays.

South Beach, l'un des quartiers les plus célèbres du monde, est un lieu de prédilection vingt-quatre heures sur vingt-quatre où richissimes et célébrissimes cabriolent à Ocean Drive dans les cafés-terrasses et les restaurants. Le district Art Déco kitsch sucré, qui abrite 400 monuments historiques protégés, est caractérisé par des rues donnant sur l'océan bordées de jolis hôtels-boutiques et de bars inondés de célébrités.

Dans sa ville caraïbe continentale, peu d'endroits ont la fascination, l'histoire et l'attrait de Miami. Jadis asile des cadres de l'industrie de la mode et paradis pour les séances photos avec les top models et les célèbres photographes, South Beach est devenue le lieu à voir et où être vu. Ces rôles initiaux n'ont pas disparu, mais ont créé la Miami d'aujourd'hui, capitale de la détente et de la flamboyance assurée. Restaurants chic et immenses salons ont commencé à faire leur apparition dans les halls d'hôtel, et un nouvel endroit génial pour les rendez-vous s'est développé.

South Beach est la Côte d'Azur américaine bondée de célébrités, aux allures de St. Tropez, mais la Côte d'Azur n'a jamais eu une plage si belle ou une vie nocturne si variée. South Beach ressemble à Cannes, gouvernée par des lanceurs de mode, où tout le monde est invité sans code vestimentaire. C'est un endroit où les Ferraris rouges prennent tout leur sens. C'est là que l'on peut se transformer.

Patrice Farameh

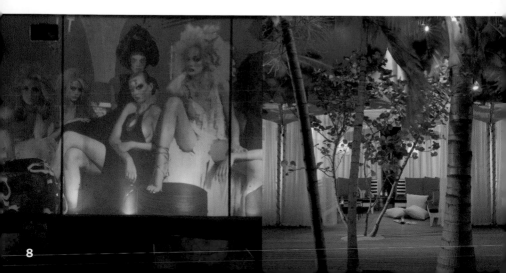

Introduzione

Si dice che non si dovrebbe giudicare un libro dalla sua copertina, ed a Miami infatti niente è mai così come appare. Le prime e le ultime impressioni cambiano costantemente. Piena di persone fantastiche e posti meravigliosi, Miami è un paradiso subtropicale lavato dalla luce brillante del Sud, baciato da un blu-verde che l'abbraccia, da acque brillanti che gentilmente si rotolano sulla spiaggia fatta di sabbia bianca. L'entusiasmo di Miami per tutte le cose sensuali viene messo in evidenza nella sua musica e nel suo cibo: salsa ritmica ed un cool jazz, una cucina che unisce i piatti a base di pesce fresco con i sapori tropicali, tutto ciò mette in evidenza una città che si dedica ai lati piccanti della vita. La Miami stimolante, seduttiva possiede molte identità: un porto quiete, un rifugio dei pensionati, la palestra delle celebrità, un paese delle meraviglie del jet-set di punta, ed una mecca per i turisti. E questo è solo un piccolo esempio di quel mondo simile ad un sogno alla Fellini che esiste qui sulla punta più lontana del Paese.

South Beach, uno dei vicinati più famosi di tutto il mondo, rappresenta 24 ore su 24 il sottofondo dove gli ultra-ricchi ed i famosi se ne vanno a spasso lungo l'Ocean Drive in caffè laterali e ristoranti di prima classe. Il distretto kitsch Art Deco coperto di dolci, casa di 400 edifici che sono monumenti nazionali, con strade che si trovano di fronte all'oceano allineate alle carine boutique hotel ed ai bar frequentati dalle celebrità.

In questa City continentale e caraibica pochi luoghi mantengono quel glamour, quella storia ed il fascino di Miami. In passato un rifugio per gli alti quadri dell'industria della Moda ed una location ideale per i foto-shooting con top-model e famosi fotografi, South Beach è diventato il luogo in cui guardare e farsi guardare. Questi ruoli iniziali hanno infine reso la Miami di oggi la capitale del divertimento ricreativo e della stravaganza pretenziosa. Ristoranti eleganti ed incredibili lounge hanno iniziato ad apparire nelle lobby degli hotel, e così si è sviluppato un luogo nuovo dove mescolarsi ed entrare in contatto con gli altri.

South Beach è la Riviera Americana satura di celebrità, con un tocco di St. Tropez, anche se la Riviera francese non ha mai avuto una spiaggia così bella, o una vita notturna così variegata. South Beach è simile a Cannes dove va chi vuol fare tendenza, dove tutti sono invitati e non c'è l'obbligo della giacca. È un luogo in cui le Ferrari rosse sono veramente sensate. È dove si può diventare qualcun'altro.

Patrice Farameh

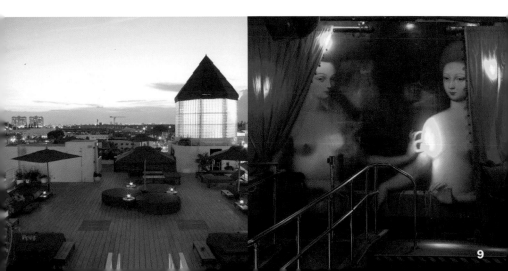

Bal Harbour Shops

9700 Collins Avenue, Bal Harbour | Miami, FL 33154 | Miami Beach
Phone: +1 305 866 0311
www.balharbourshops.com
Opening hours: Mon–Sat 10 am to 9 pm, Sun noon to 6 pm
Special features: Exclusive high-end fashion shopping experience

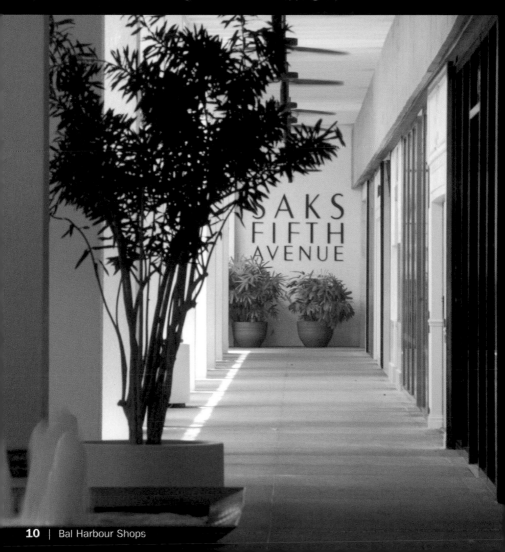

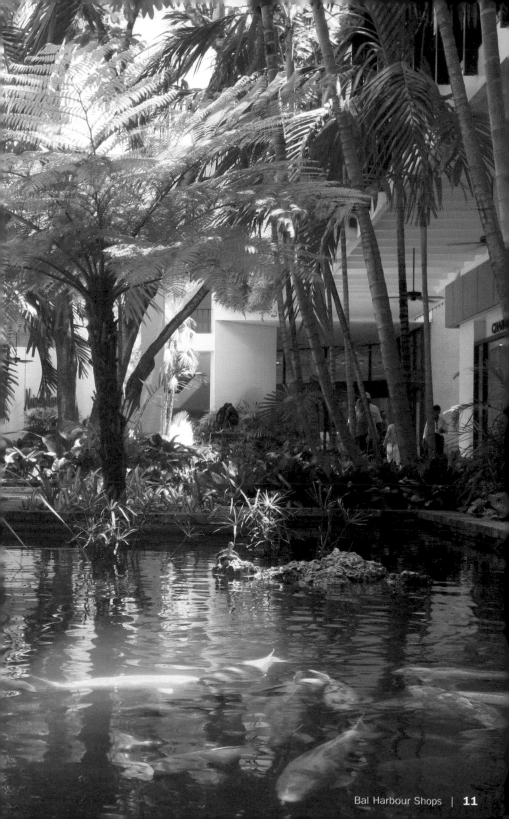

Casa Casuarina

Design: Alison Antrobus

1116 Ocean Drive | Miami, FL 33139 | Miami Beach
Phone: +1 305 672 6604
www.casacasuarina.com
Special features: Former Miami residence of Gianni Versace turned into hotel with exclusive spa area; private invitation-only membership club

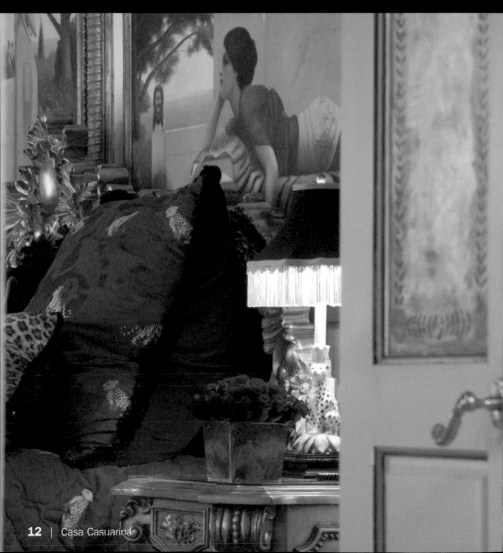

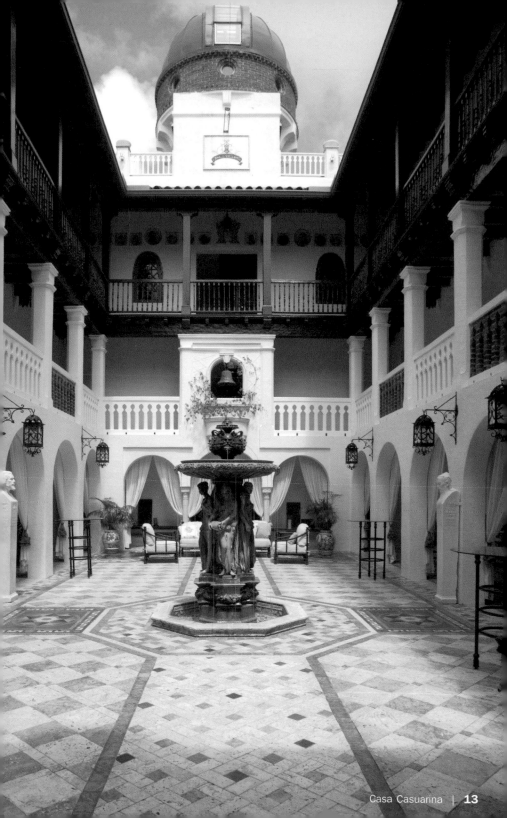

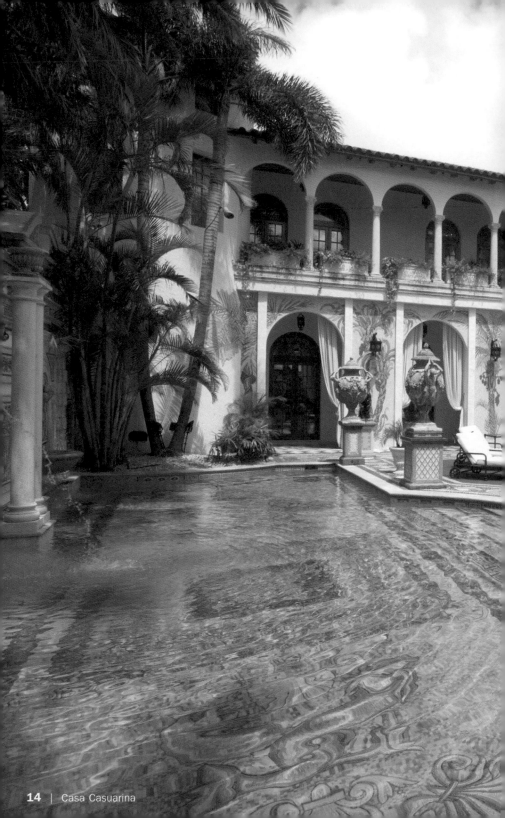

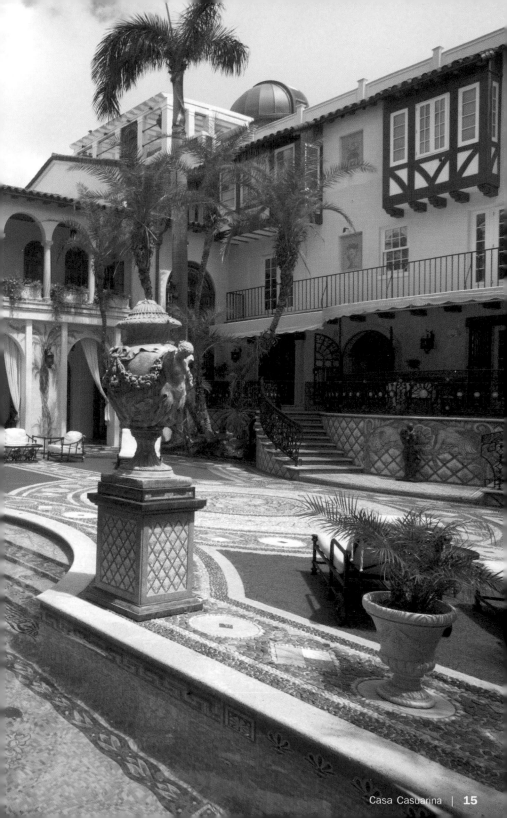

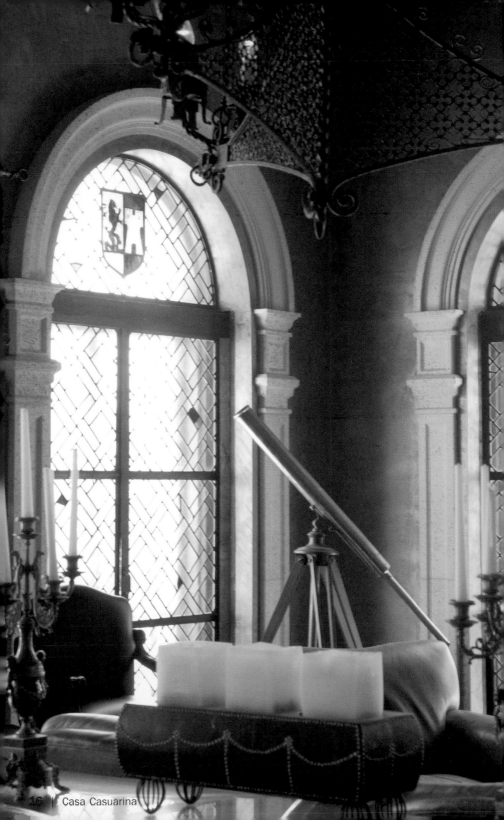

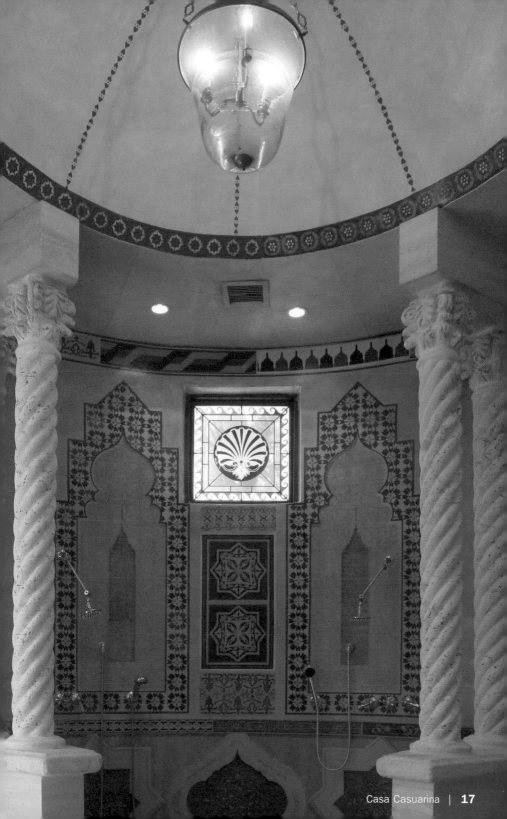

Casa Tua

Design: Michele Bonan

1700 James Avenue | Miami, FL 33139 | Miami Beach
Phone: +1 305 673 0973
www.casatualifestyle.com
Special features: Chic Mediterranean-style villa refurbished as a club, restaurant with outdoor garden, and boutique hotel

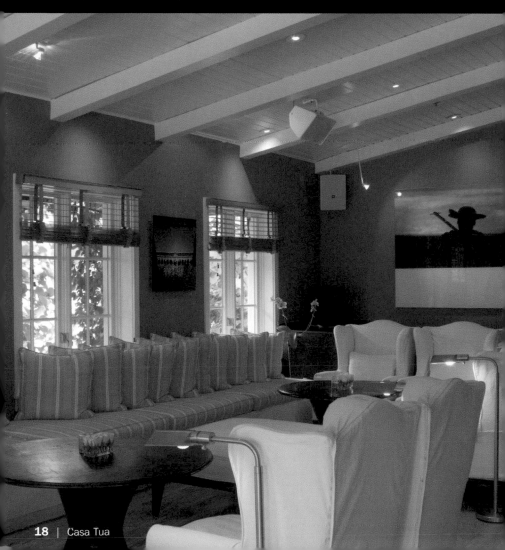

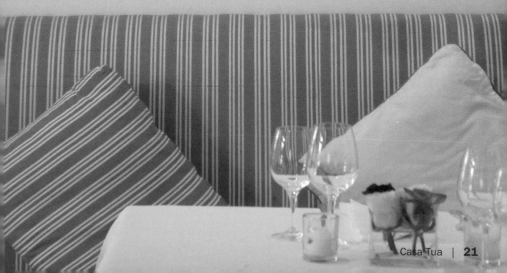

Clinton South Beach

Design: Eric Raffy

821 Washington Avenue | Miami, FL 33139 | Miami Beach
Phone: +1 305 938 4040
www.clintonsouthbeach.com
Opening hours restaurant: Mon–Sun 7 am to 2 am
Special features: An oasis on the vibrant Washington Avenue. Best location for lunch meetings or poolside candlelight dinners in the restaurant "8½ global creative cuisine"

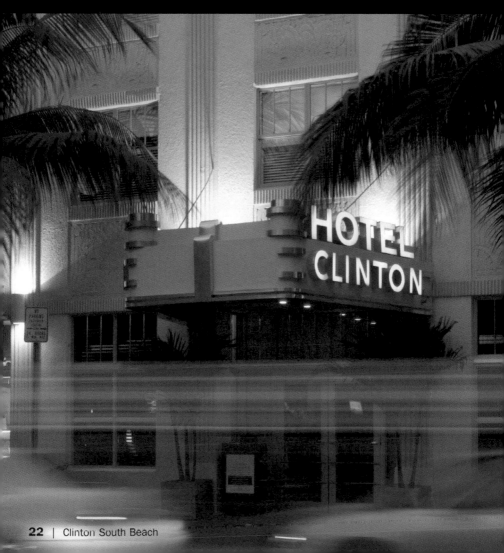

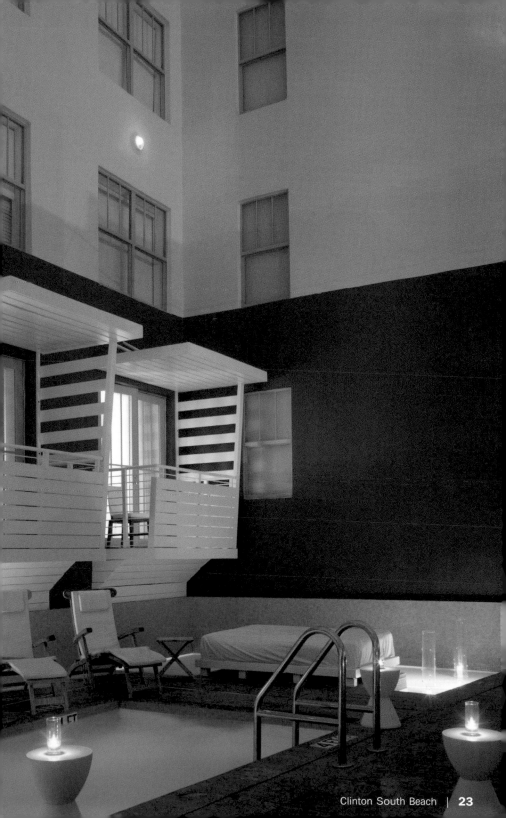

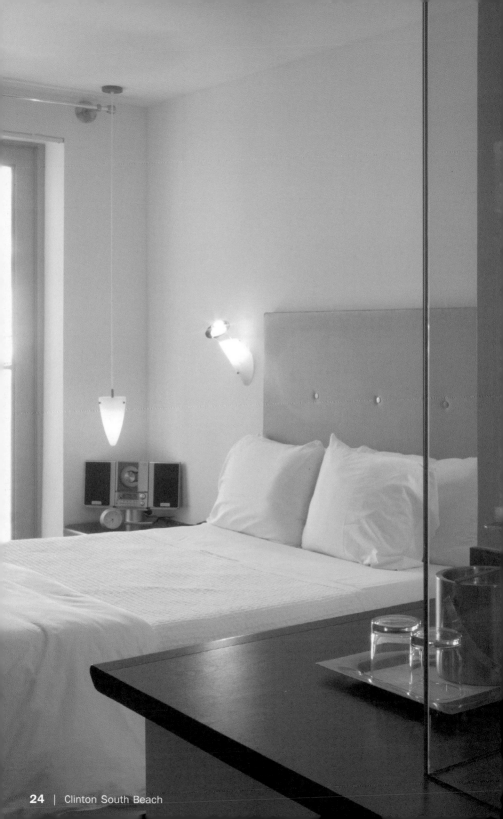

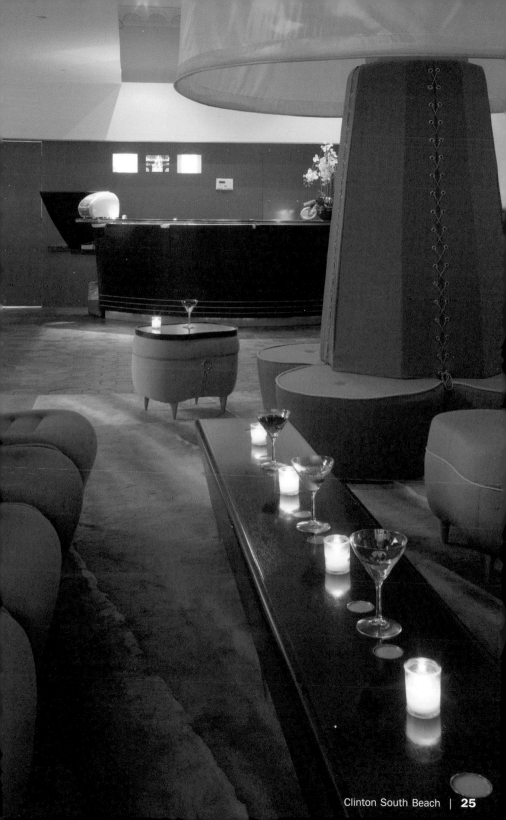

Hotel Astor

Design: Kennedy Paige & Associates

956 Washington Avenue | Miami, FL 33139 | Miami Beach
Phone: +1 305 531 8081
www.hotelastor.com
Special features: Sense of serenity in bustling South Beach zone

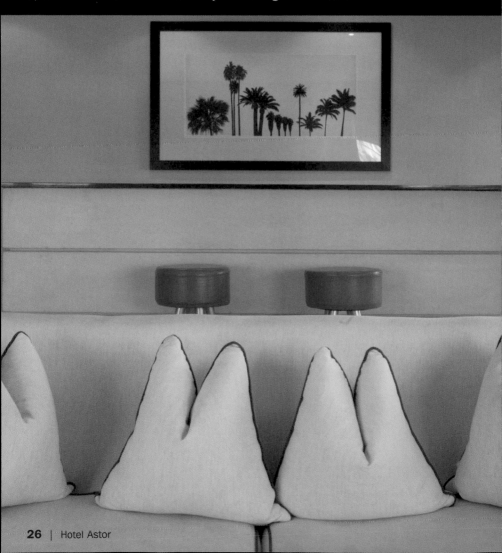

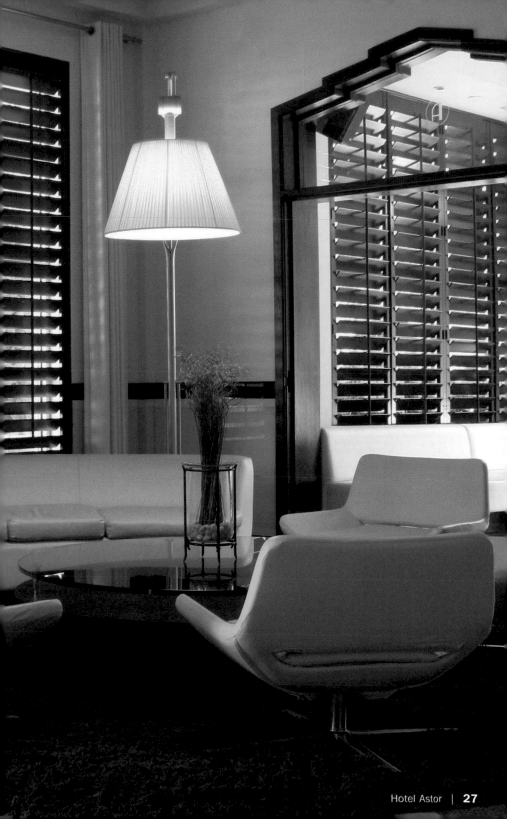

Hotel Victor

Design: Jacques Garcia

1144 Ocean Drive | Miami, FL 33139 | Miami Beach
Phone: +1 305 428 1234
www.hotelvictorsouthbeach.com
Special features: Opulent Asian-motif inspired hotel right on vibrant Ocean Drive

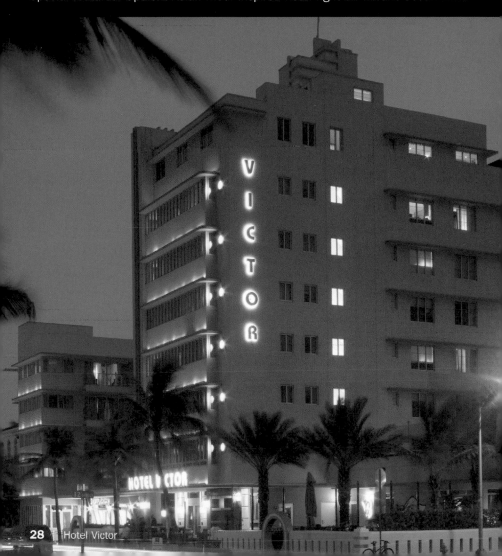

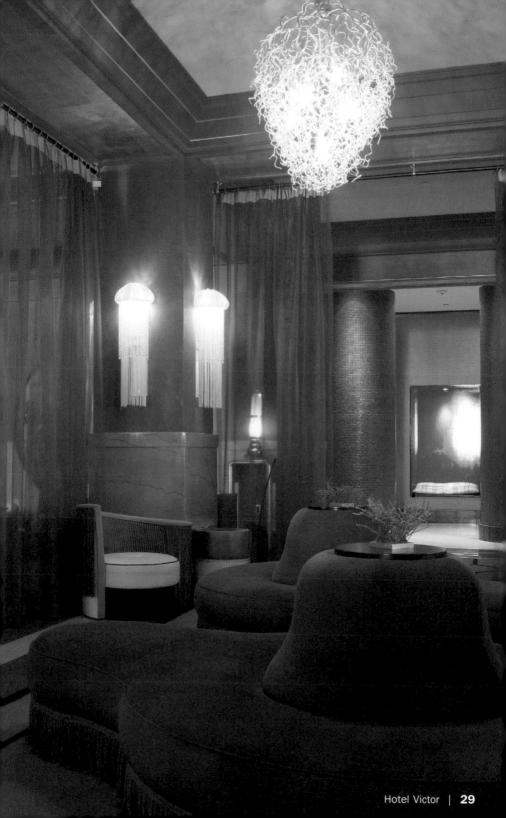

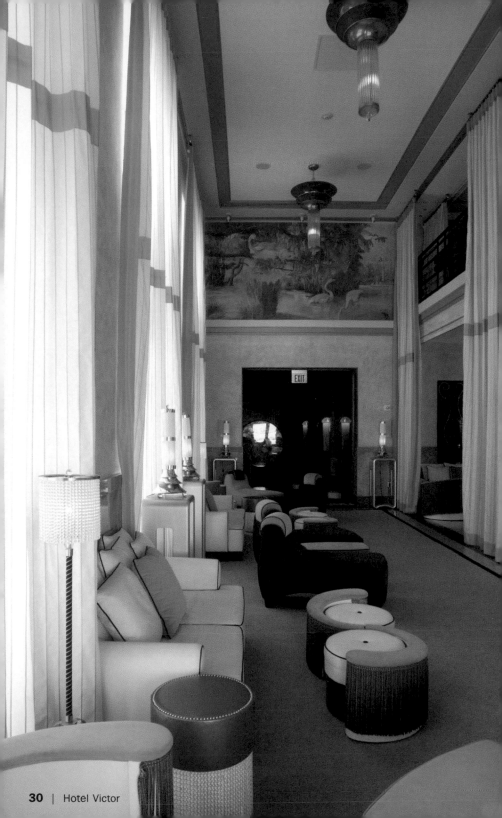

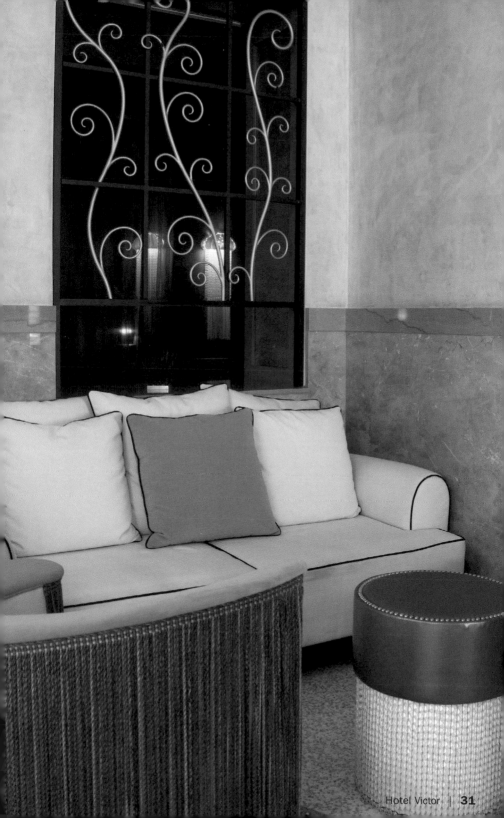

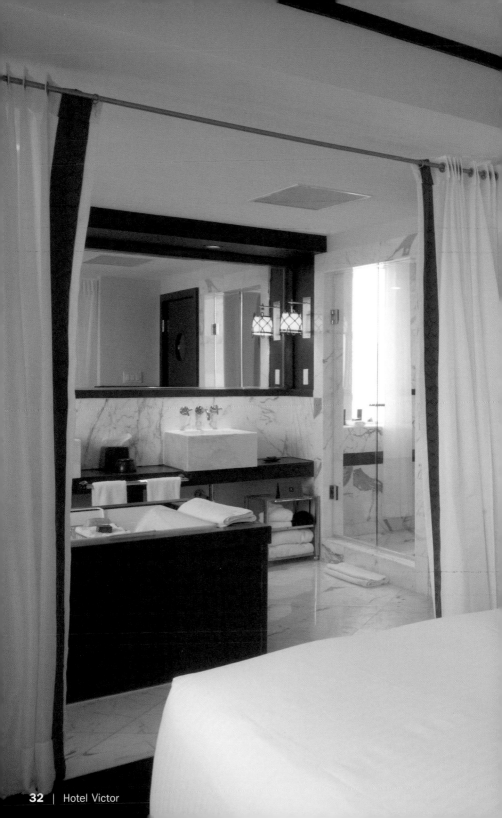

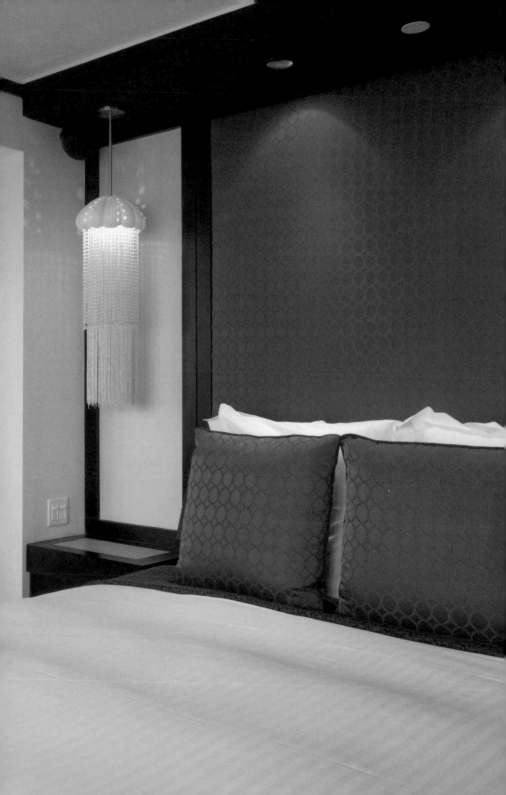

Johnny V

Design: Sam Robin

956 Washington Avenue | Miami, FL 33139 | South Beach
Phone: +1 305 531 8081
www.hotelastor.com
Opening hours: Sun–Thu 7 pm to midnight, Fri and Sat 7 pm to 1 am
Best day: Tuesdays
Special features: Weekly see-and-be-seen parties in contemporary, Neo Art Deco
setting with paradisiacal outdoor garden

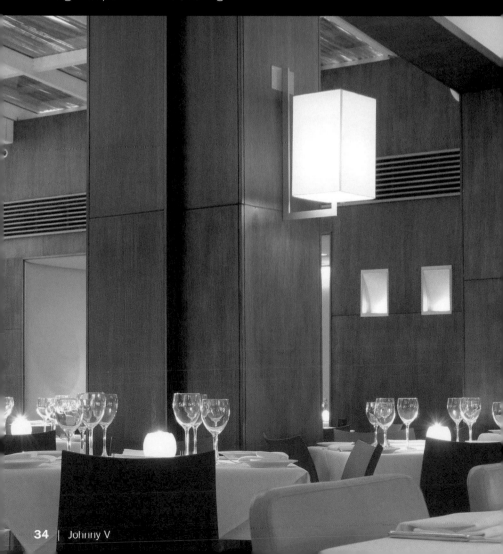

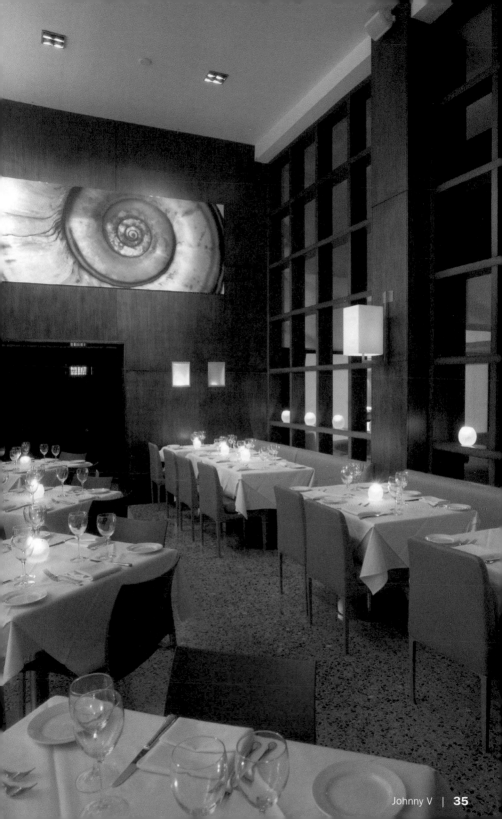

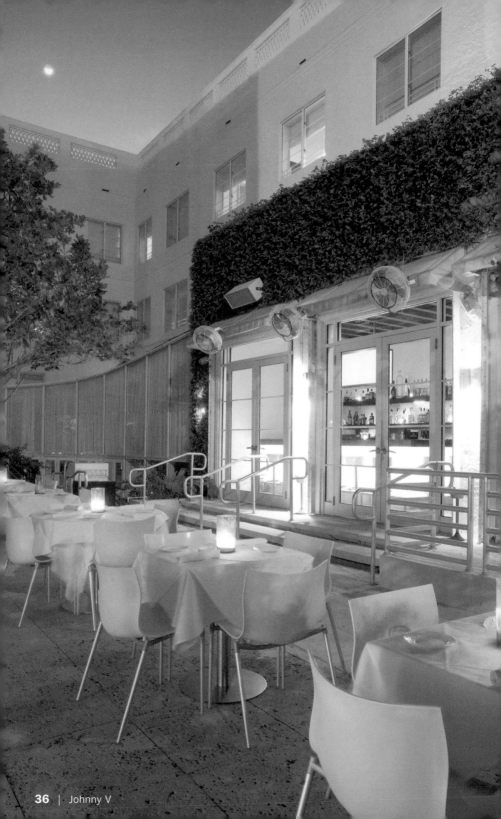

Lincoln Road

Main scene between Washington Avenue and Alton Road | Miami, FL 33139 | Miami Beach
Special features: Abundance of outdoor cafes, chic boutiques and bookstores in this
lively pedestrian only street

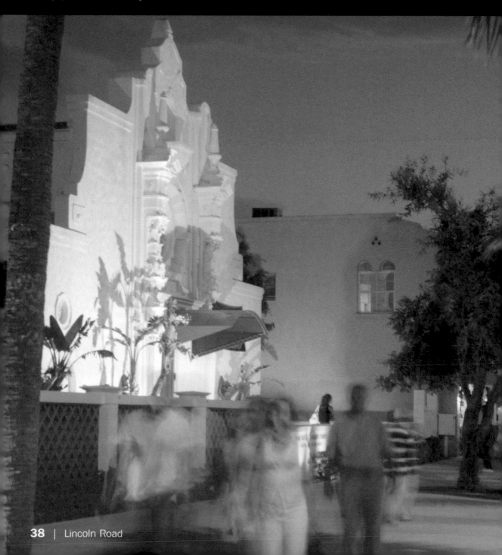

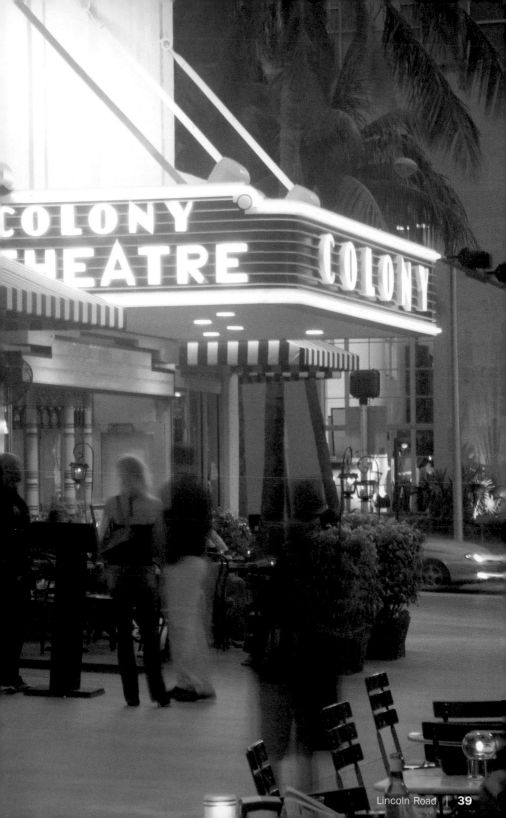

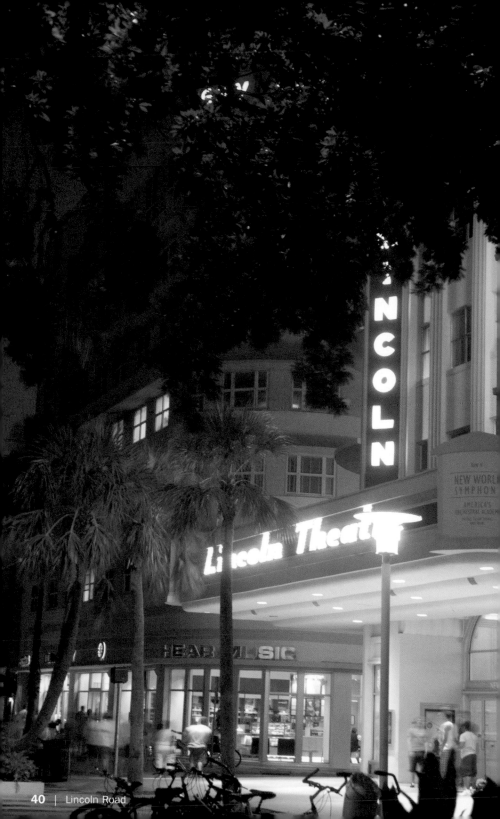

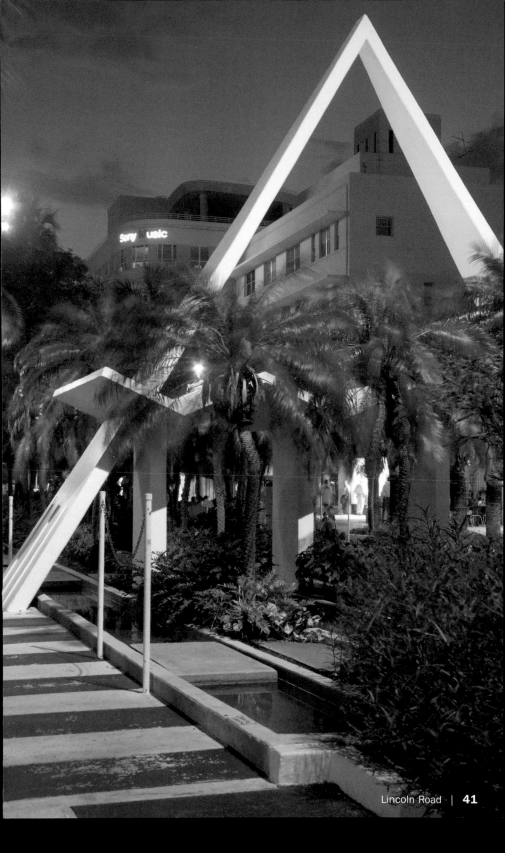

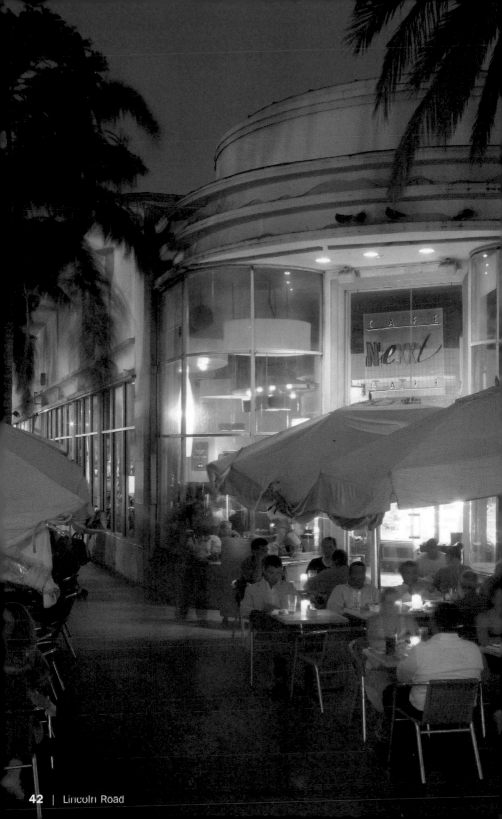

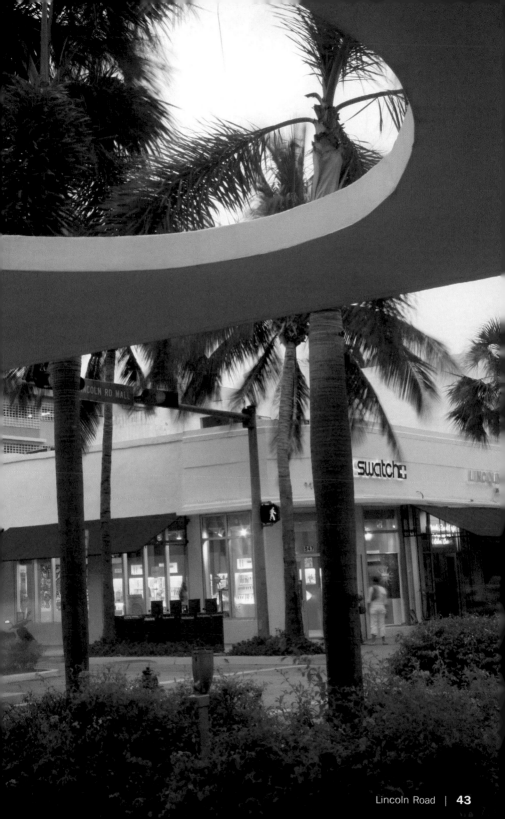

Mandarin Oriental Miami

Hotel Architect: RTKL Associates out of Dallas
Hotel and Spa designer: Hirsch Bedner & Associates of Atlanta
Restaurants: Tony Chi and Associates of New York

500 Brickell Key Drive | Miami, FL 33131 | Miami
Phone: +1 305 913 8383
www.mandarinoriental.com/miami
Special features: 20,000-square-foot white sand beach club, complete with beds
with white cushions and canopies, beach butlers, and beachside cabana treatments

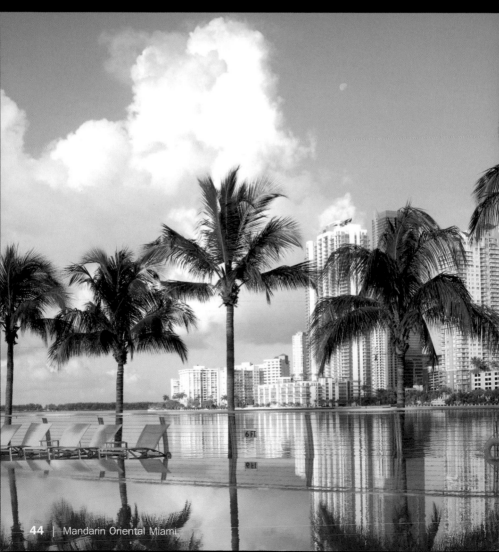

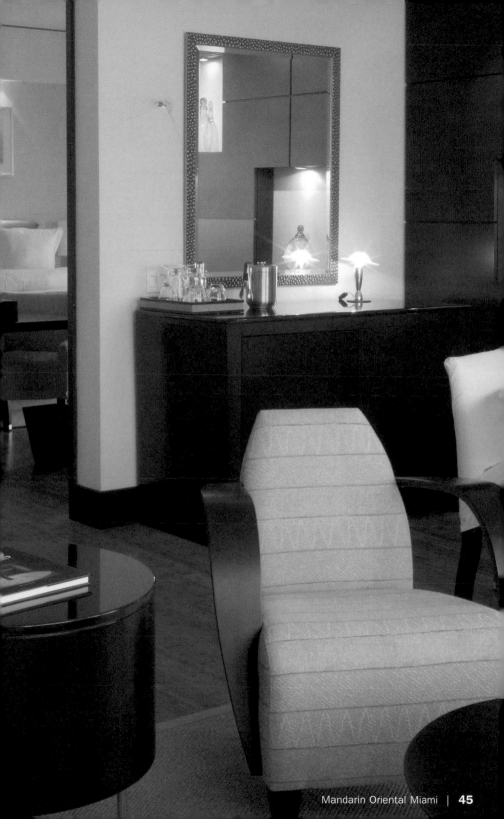

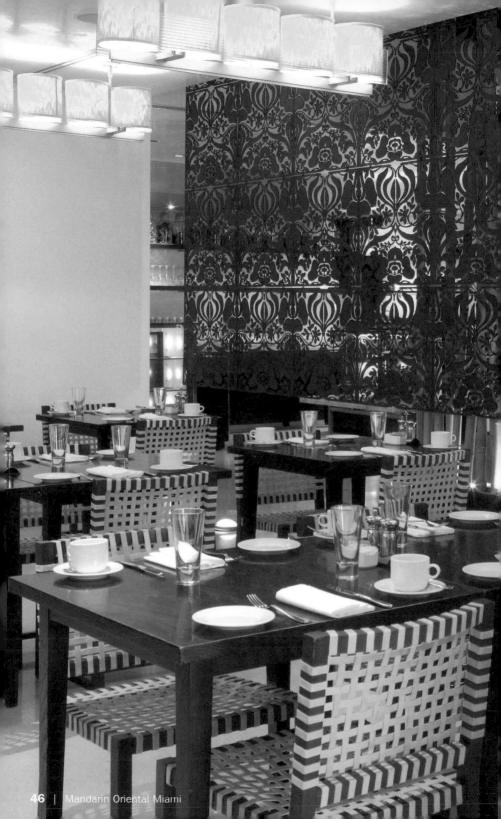

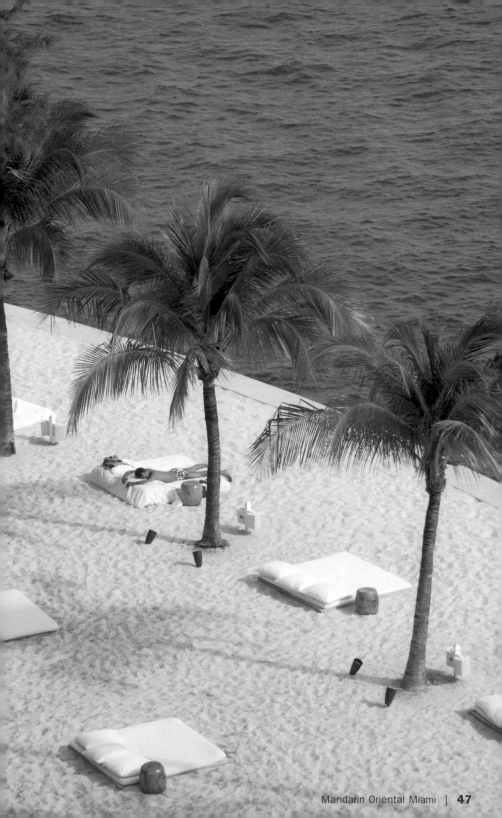

Miami Design District

Main scene between 36th and 41st Street, bounded by North Miami Avenue and Biscayne Boulevard | Miami, FL 33137 | Downtown Miami
www.miamidesigndistrict.net
Opening hours: Mainly Mon–Sat, some may vary
Special features: Over 17 art galleries and a mecca for home furnishings and interior design, including 12 fashionable eateries

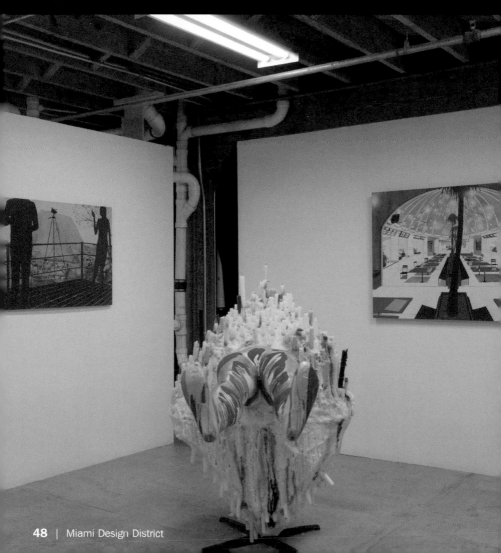

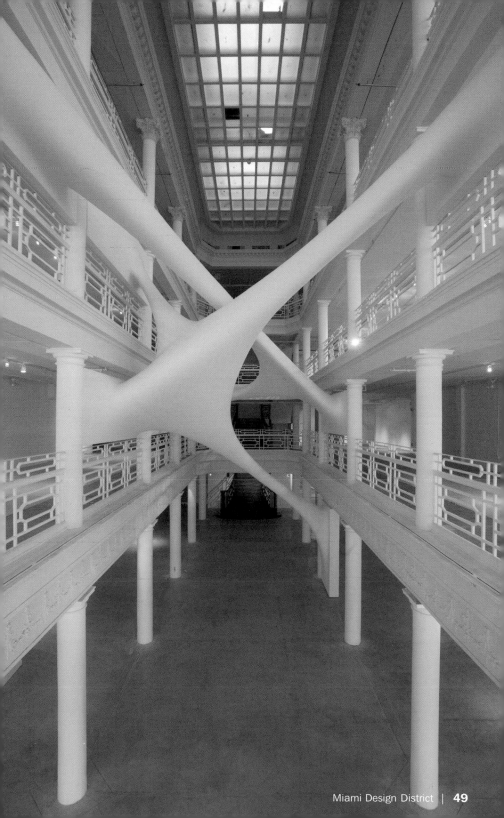

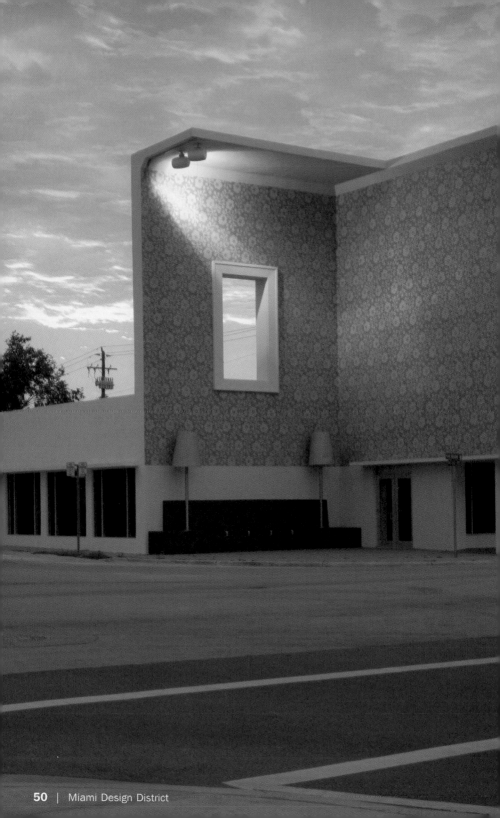

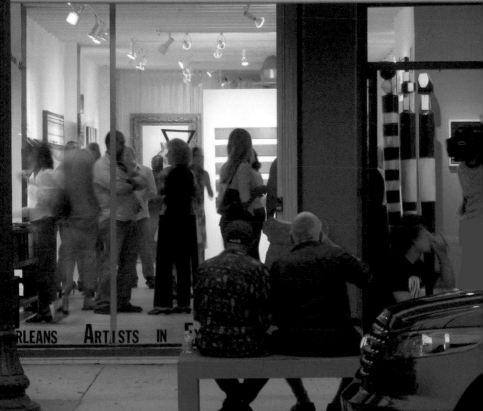

STEVE MARTIN STUDIO

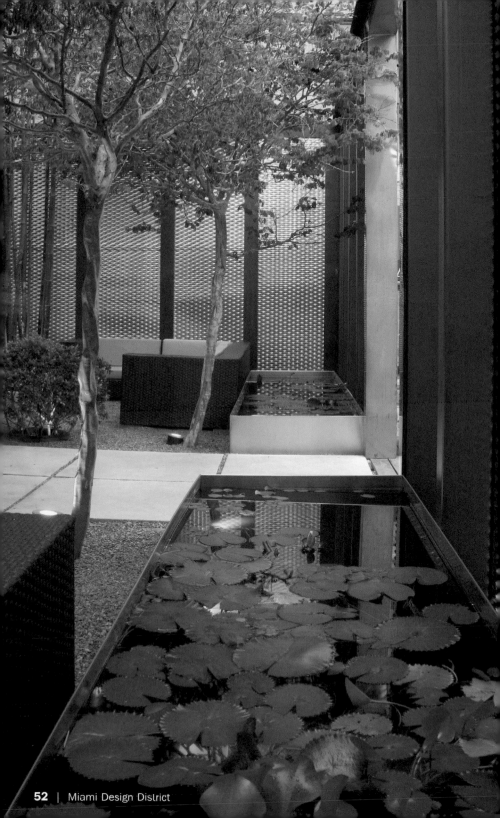

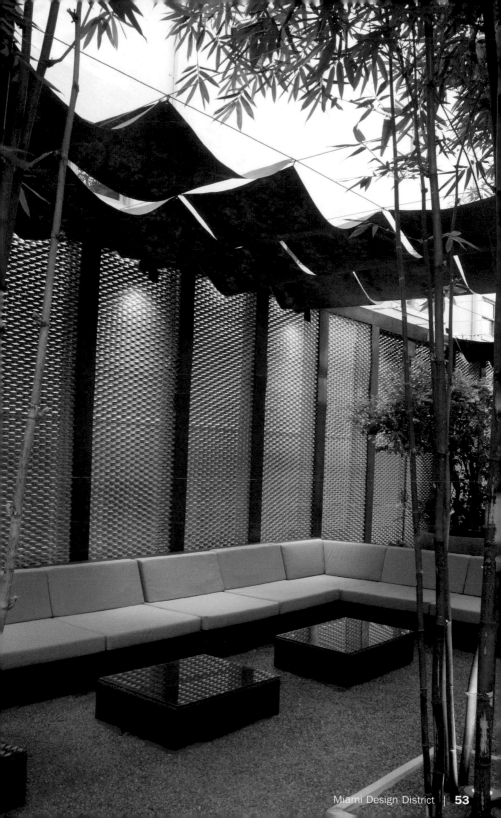

Mynt Lounge

Design: Roberto Caan in association with Francisca Heinz from Hibo designs

1921 Collins Avenue | Miami, FL 33139 | Miami Beach
Phone: +1 786 276 6132
www.myntlounge.com
Opening hours: Thu–Sat 11 pm to 5 am
Special features: Favorite hangout for fashionistas, model types, and hip locals. Beautiful people are displayed on a 40-foot-wide light box and a ventilation system disperses 50 aromatherapy scents

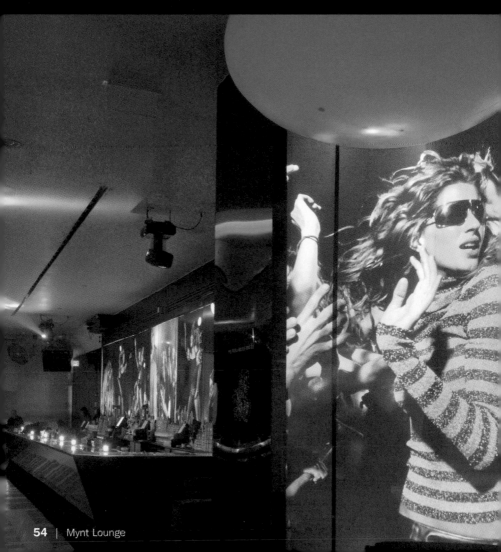

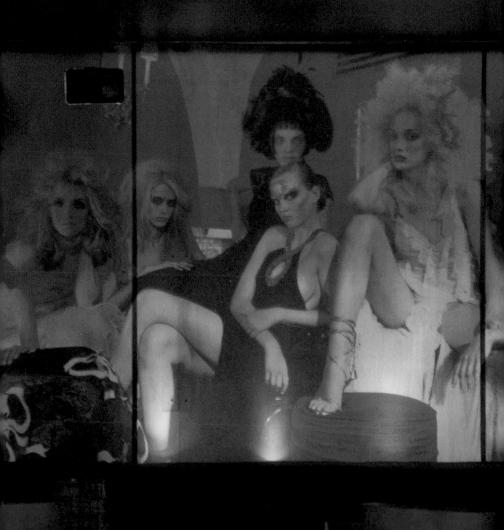

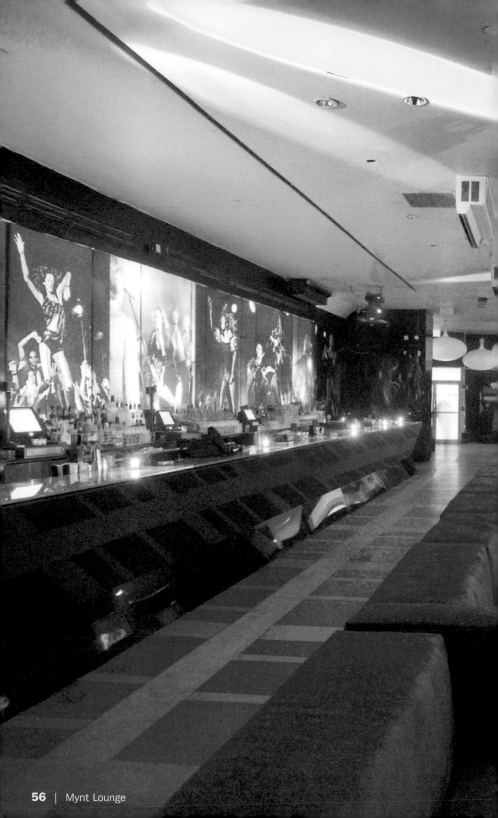

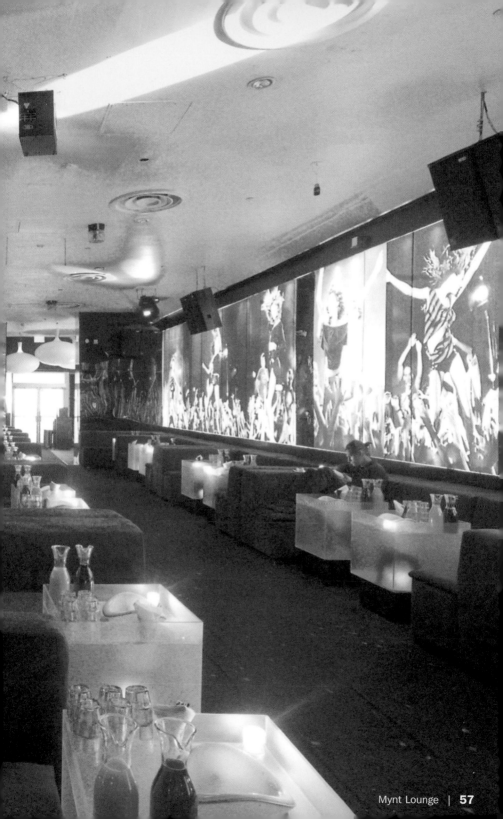

Nikki Beach

Design: Adam T. Tihany

1 Ocean Drive | Miami, FL 33139 | Miami Beach
Phone: +1 305 538 1111
www.nikkibeach.com
Opening hours: Mon–Sun 11 am to 2 am, kitchen Mon–Sat 11 am to 5 pm,
Sun 11 am to 10 pm
Best day: Sundays
Special features: Trendy beachfront bar with private cabanas, showers, and
hammocks filled with South Beach nightlife royalty

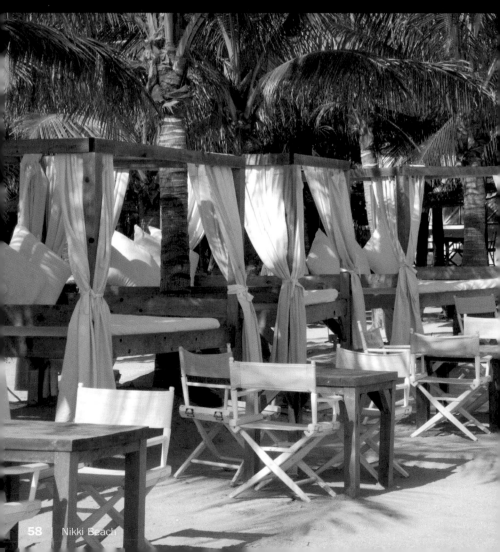

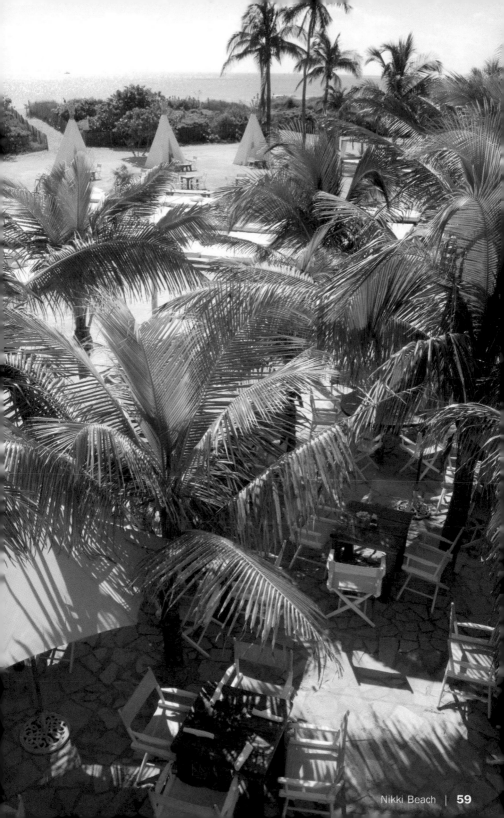

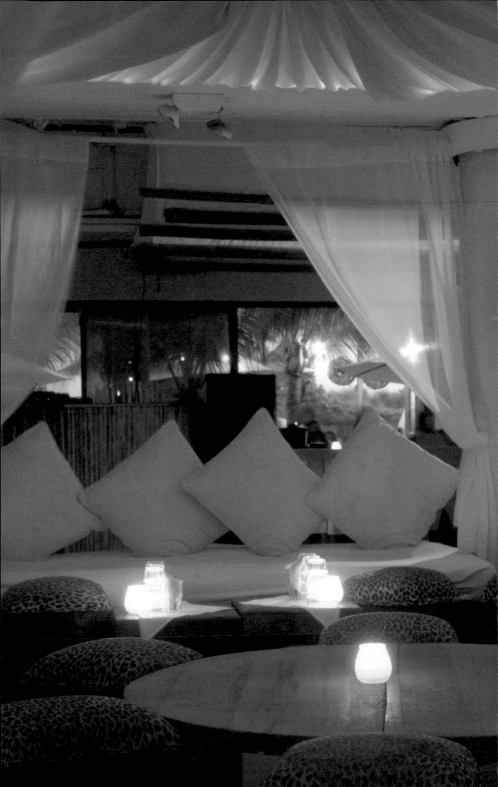

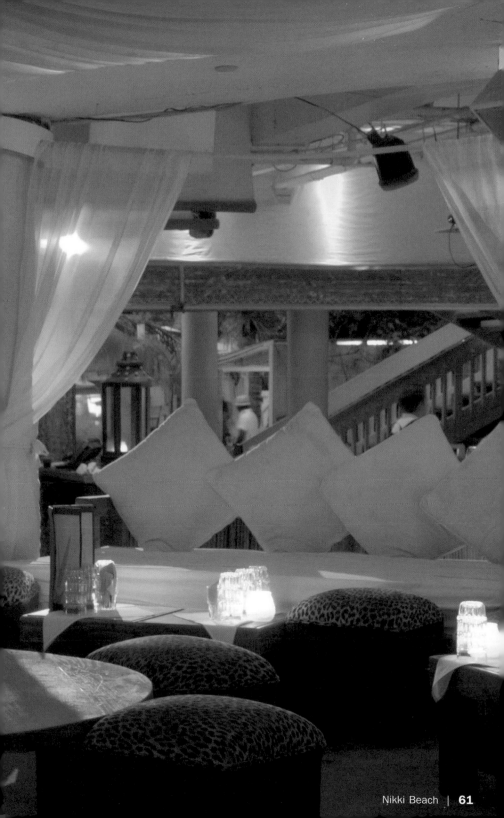

Nobu

Design: David Rockwell

1901 Collins Avenue | Miami, FL 33139 | Miami Beach
Phone: +1 305 695 3232
Opening hours: Mon–Thu 7 pm to noon, Fri–Sat 7 pm to 1 am, Sun 7 pm to 11 pm, reservations for 6 or more only
Special features: Asian inspired décor at the hottest celebrity-soaked restaurant in town. Dine on the best Japanese fusion menu the infamous sushi chef Matsuhisha has to offer

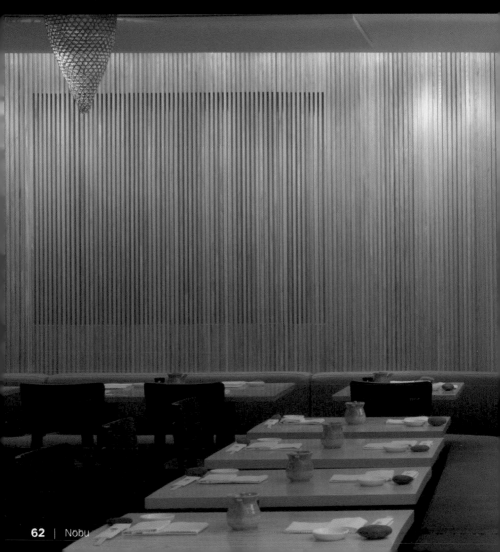

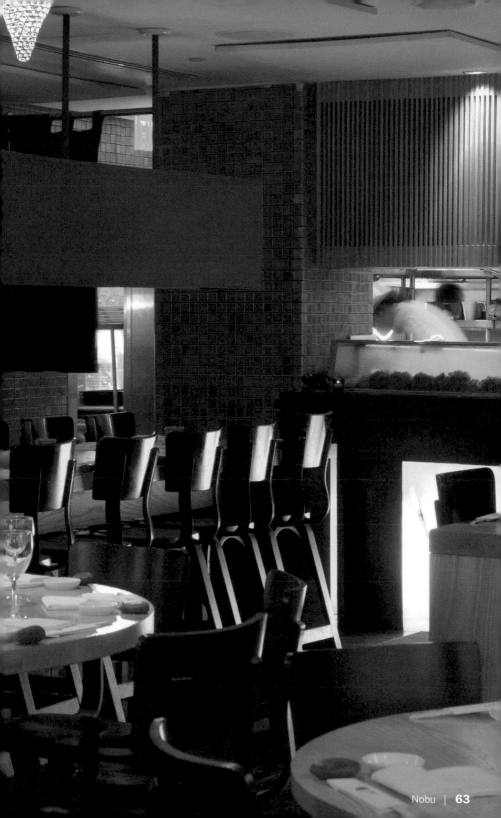

Ocean Drive

Main scene between 5th and 15th Street | Miami, FL 33139 | South Beach
Special features: Miami's most popular oceanfront promenade lined with bars,
shops, restaurants, and hotels with the world's best Art Deco architecture

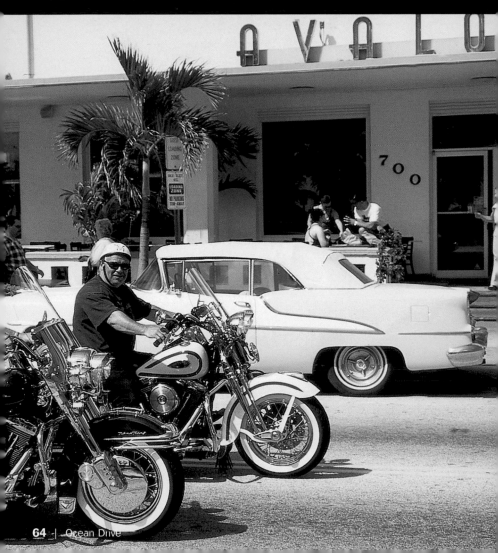

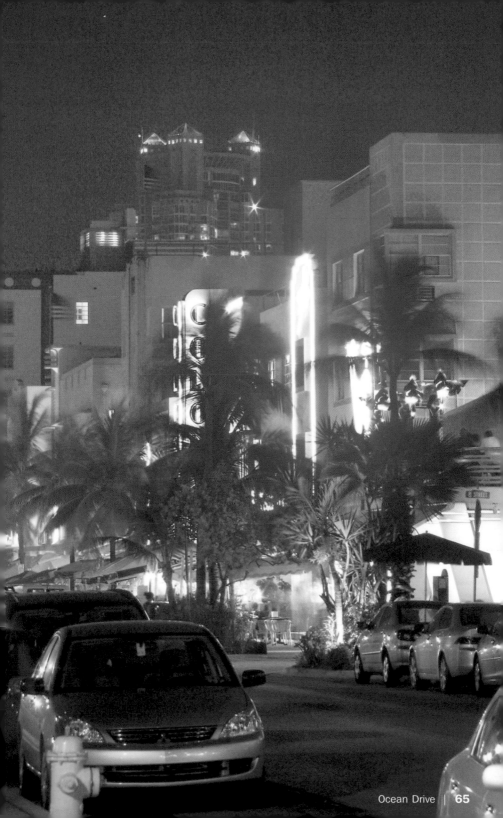

Opium Garden

Design: Francois Frossard Design

136 Collins Avenue | Miami, FL 33139 | Miami Beach
Phone: +1 305 531 5535
www.theopiumgroup.com
Opening hours: Thu–Sat 11 pm to 5 am, available seven days a week for special events
Best day: Fridays
Special features: Gorgeous oriental-styled outdoor venue with long white drapes, pagodas, buddhas, elaborate lighting and laterns, and filled with an even more attractive crowd

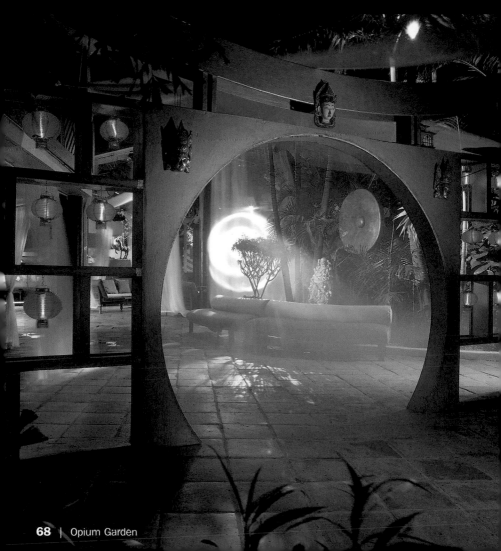

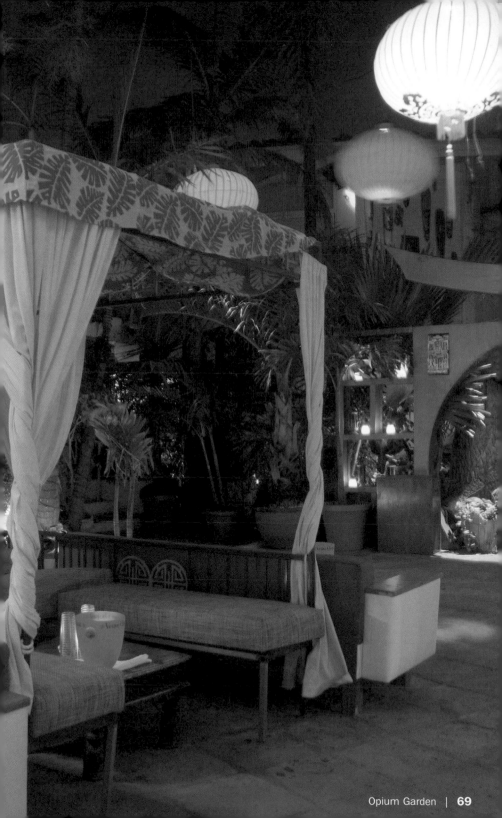

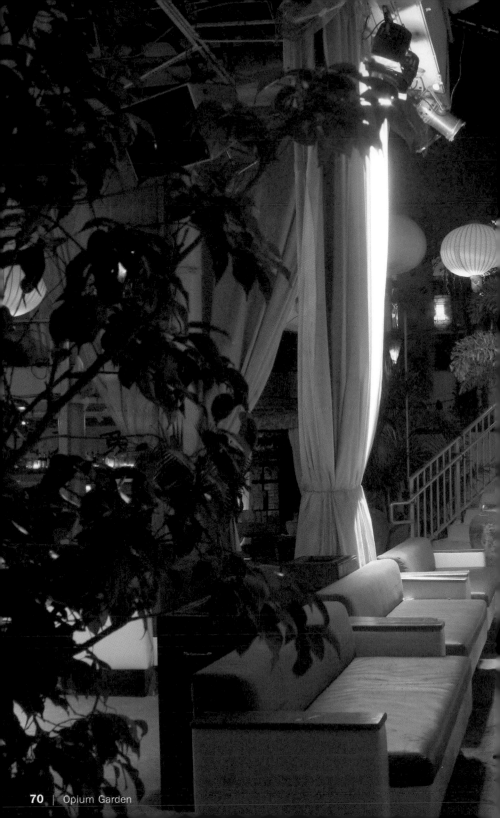

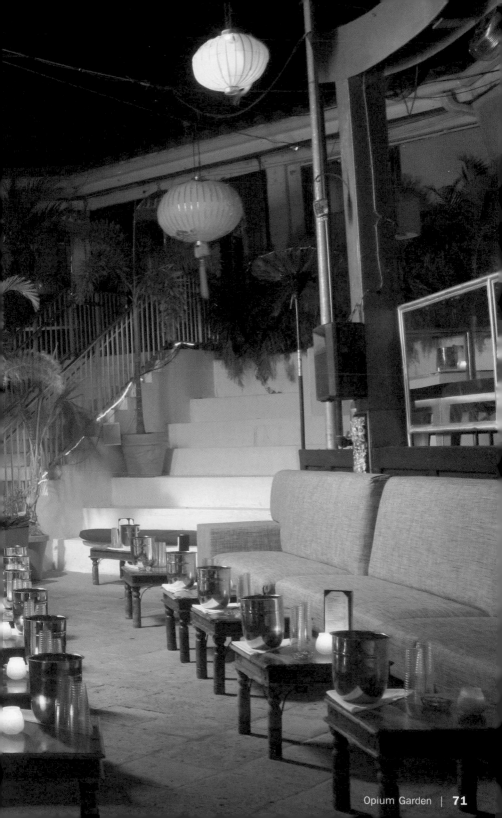

Pearl

Design: Stephane Dupoux, Lubna Zawawi

1 Ocean Drive | Miami, FL 33139 | Miami Beach
Phone: +1 305 538 1111
www.pearlsouthbeach.com
Opening hours: Wed–Thu 7 pm to 11 pm, Fri–Sat 7 pm to 1 am, lounge 7 pm to 5 am
Best day: 80's Freeze Frame Night on Thursdays, Rock Star Sundays
Special features: Super-hot, voguish 380-seat, orange-hued restaurant and lounge
with amber lighting and a pearl-shaped bar for sampling champagne and caviar

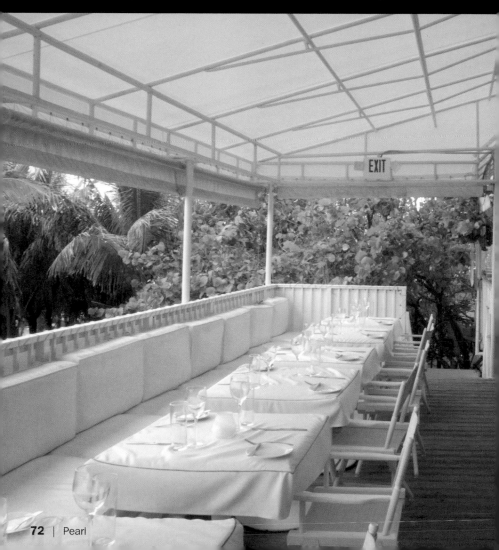

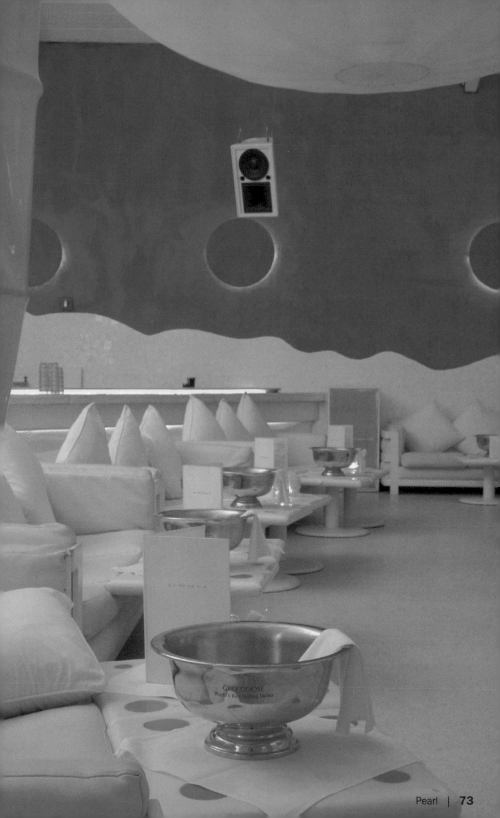

Prime 112

Design: Alison Antrobus, Allan Shulman

112 Ocean Drive | Miami, FL 33139 | Miami Beach
Phone: +1 305 532 8112
www.prime112.com
Opening hours: Lunch Mon–Fri noon to 3 pm,
dinner Sun–Thu 6:30 pm to midnight, Fri–Sat 6:30 pm to 1 am
Special features: Sleek steakhouse ambience with bustling bar filled with powerhouse
crowd serving the best beef in town, including their signature Kobe Beef Burger

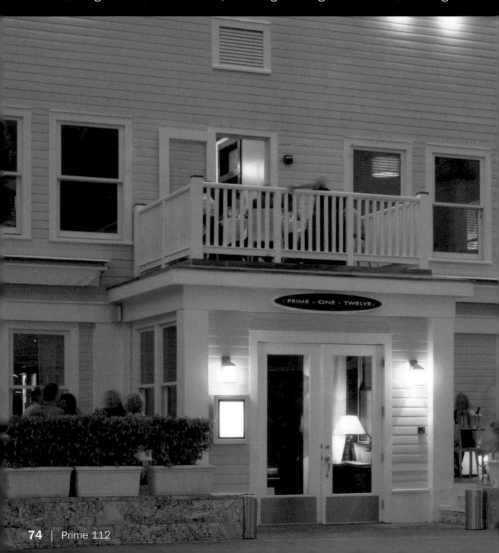

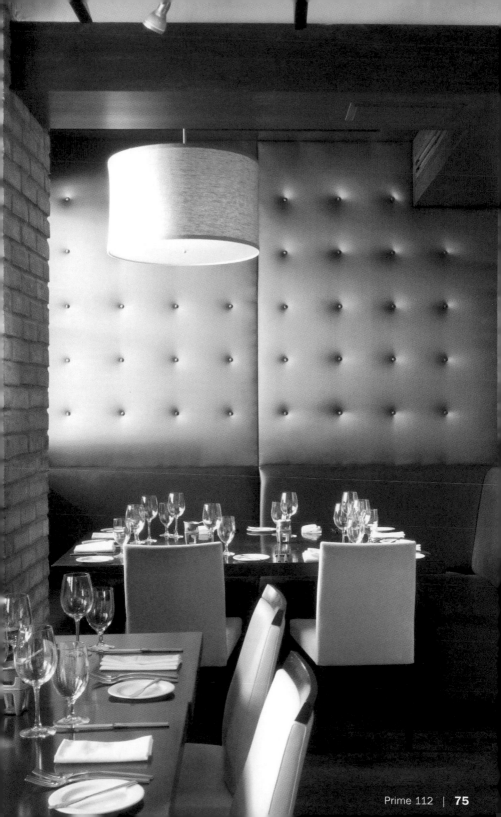

Privé

Design: Nicole Bailey Design

136 Collins Avenue | Miami, FL 33139 | Miami Beach
Phone: +1 305 531 5535
www.theopiumgroup.com
Opening hours: Thu–Sat 11 pm to 5 am, available seven days a week for special events
Special features: 30,000-square-foot mega nightclub inspired by Far East philosophies
created with A-list celebrities and South Beach trendsetters in mind

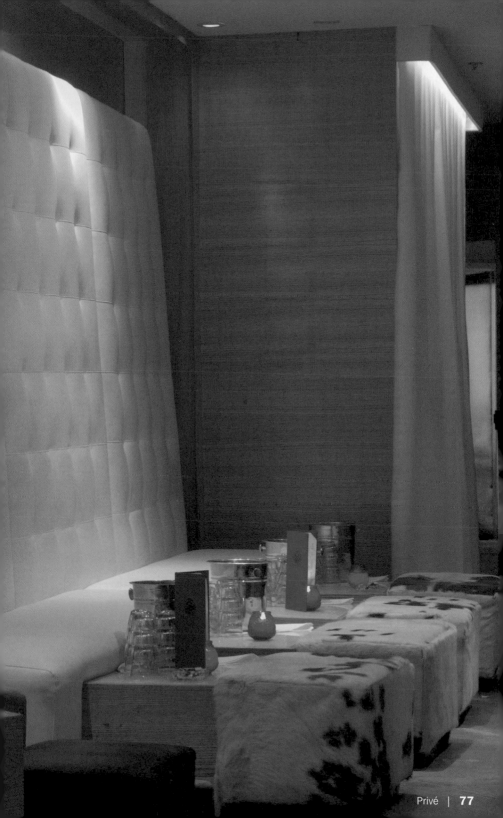

Ritz Carlton South Beach

Architect: Nichols, Brosch, Sandoval
Design: Howard Design Group, lead designer: Zeke Fernandez

1 Lincoln Road | Miami, FL 33139 | Miami Beach
Phone: +1 786 276 4000
www.ritzcarlton.com/resorts/south_beach
Special features: Restored 1950s DiLido Hotel with an impressive $2 million art collection of original works. Elevated pool has unobstructed views of the Atlantic with your own tanning butler

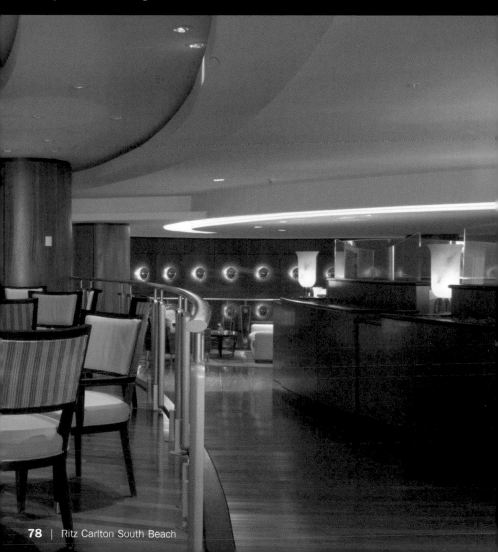

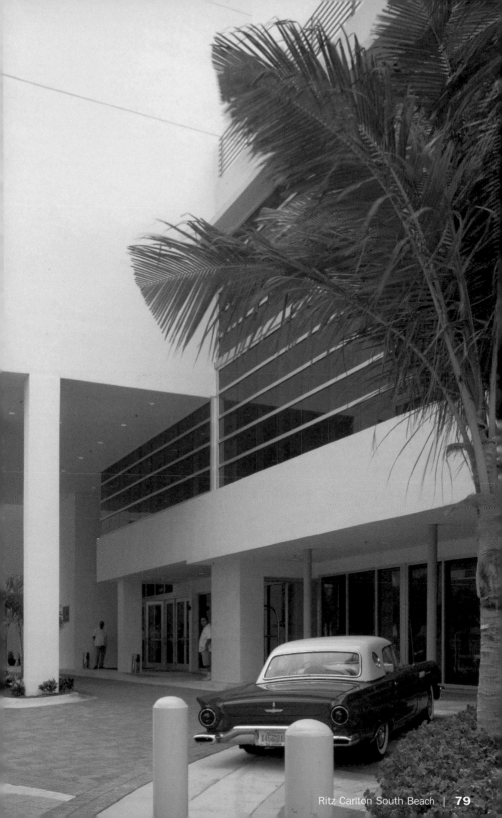

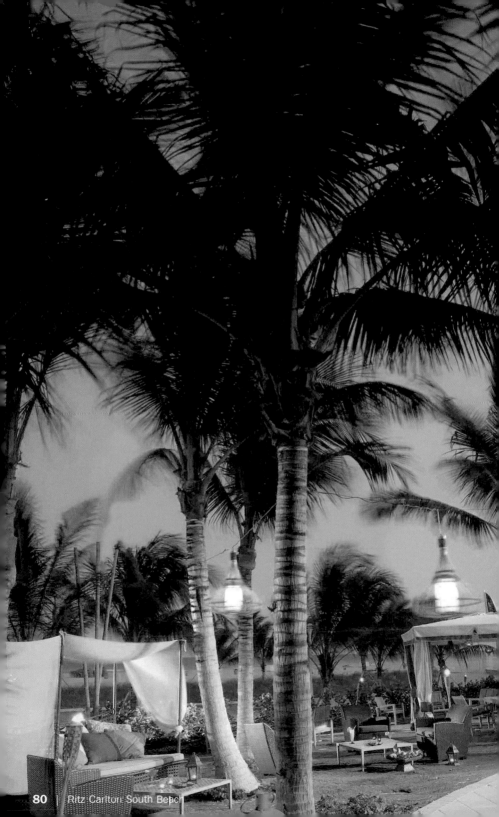

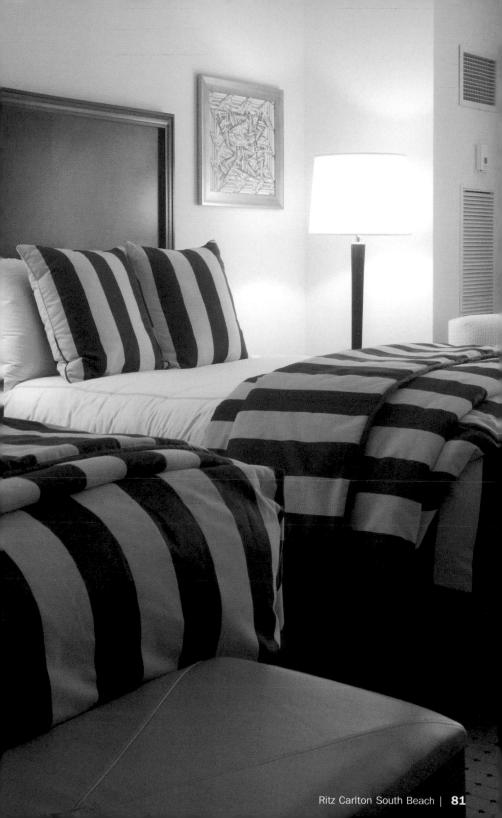

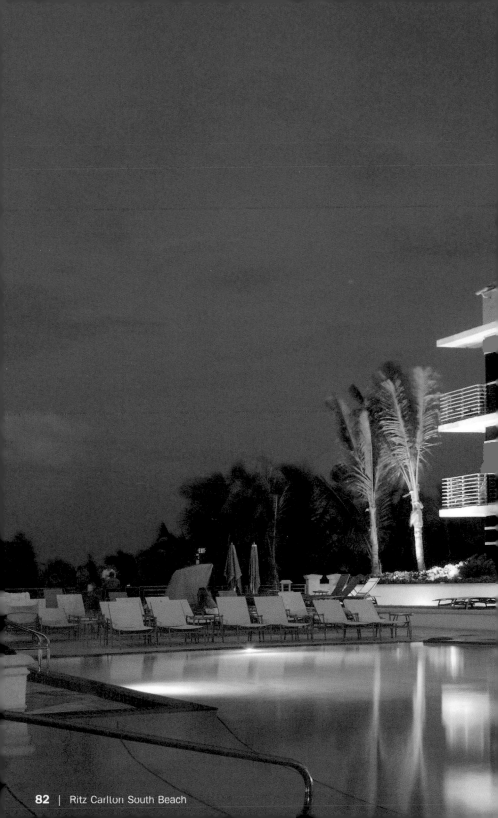

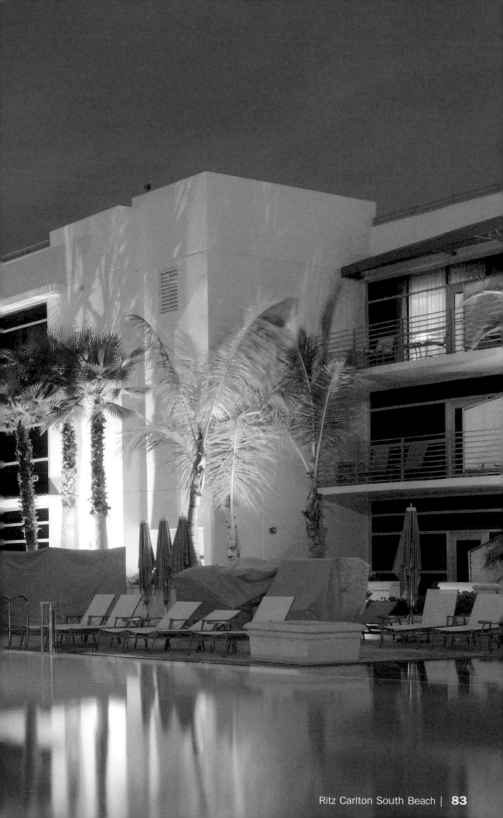

Rok Miami

Design: Sean Saladino

1905 Collins Avenue | Miami, FL 33139 | Miami Beach
Phone: +1 305 538 7171
www.rokbarmiami.com
Opening hours: Tue, Thu–Sun 11 pm to 5 am
Best day: Tuesdays
Special features: "Anti-club" owned by rocker Tommy Lee

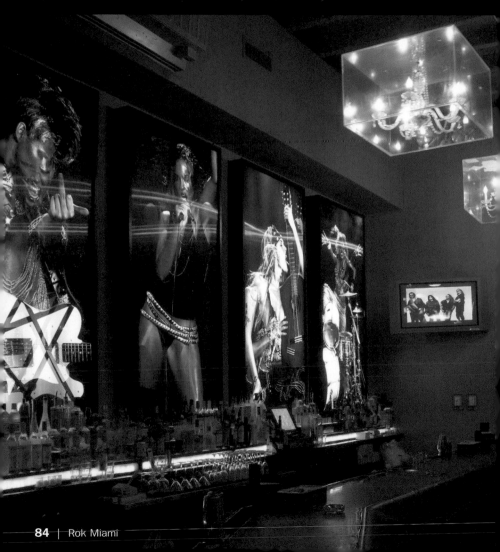

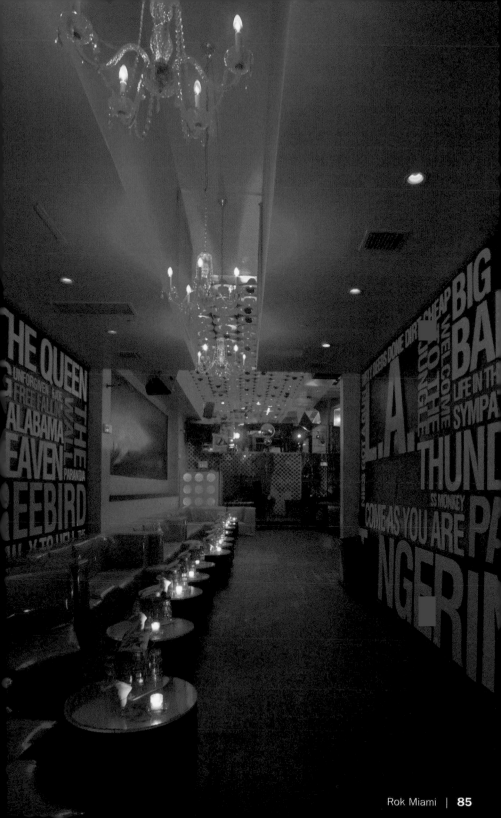

Snatch

Design: Mark Lehmkuhl in collaboration with Sculptors of Space

1437 Washington Avenue | Miami, FL 33139 | Miami Beach
Phone: +1 305 604 3644
www.www.snatchmiami.com
Opening hours: Tue–Sat 11 pm to 5 am
Special features: Rock'n'Roll decadence with an eclectic décor. Designer lingerie hangs from antlered chandeliers and a glass-encased Rose bar completes its rockstar chic ambience

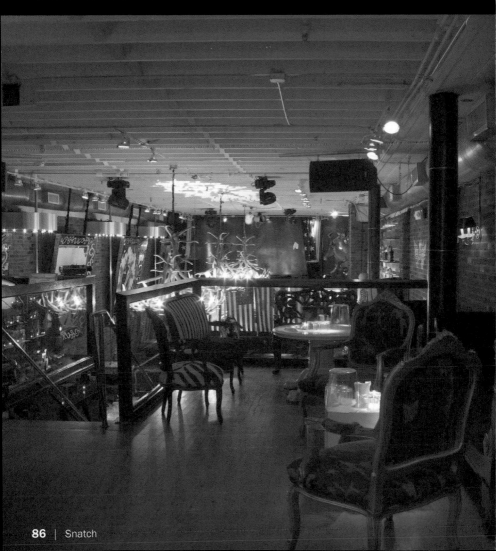

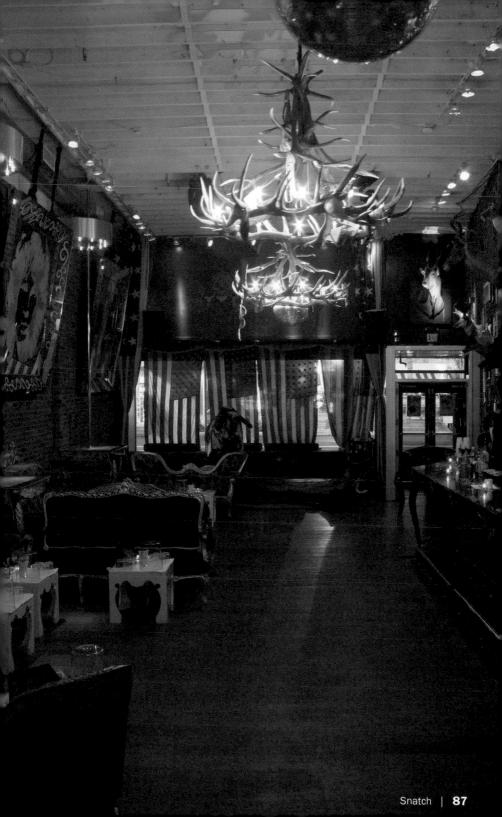

Spire Bar & Lounge

Design: Todd Oldham

801 Collins Avenue | Miami, FL 33139 | Miami Beach
Phone: +1 305 531 2222
www.thehotelofsouthbeach.com/pool_spire.htm
Opening hours: Thu–Sat 7 pm to 1 am
Special features: Designed with pink and orange floorboards and plushy white sofas.
Perfect place for listening to mellow music enjoying the spectacular oceanfront views
while sipping on their delicious neon martinis

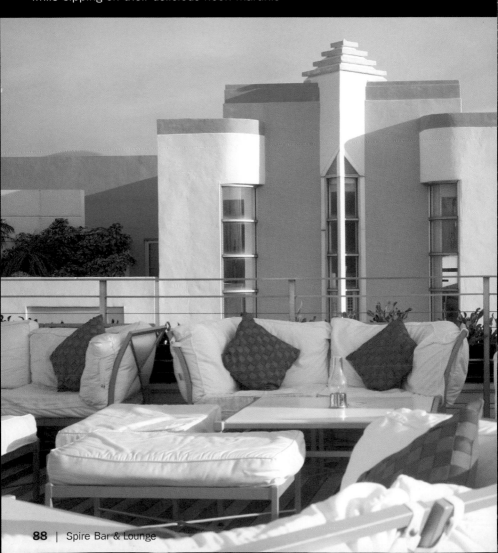

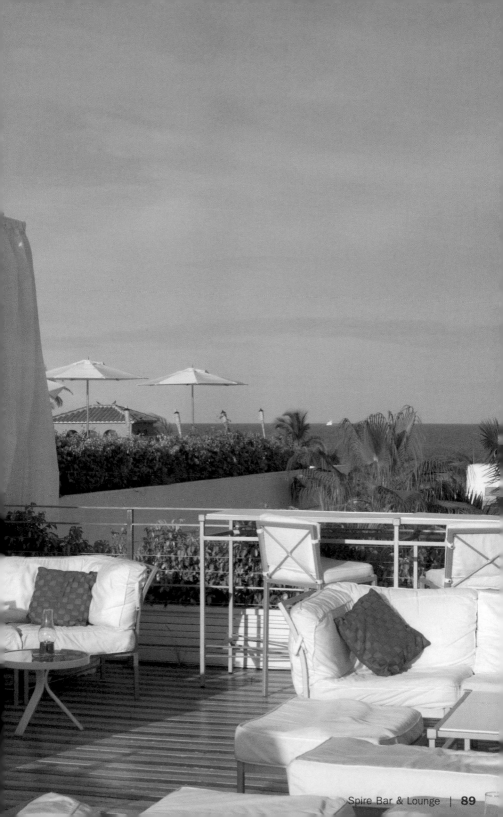

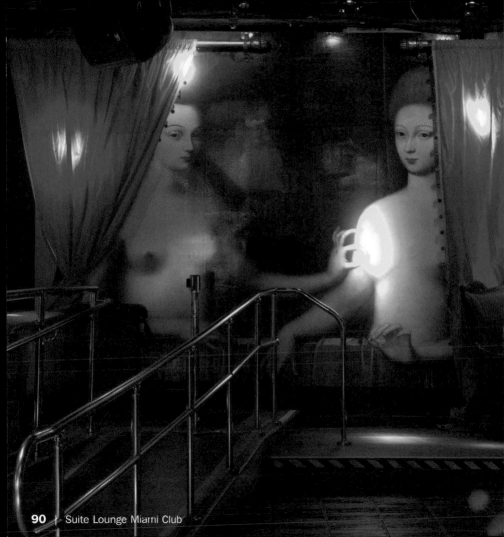

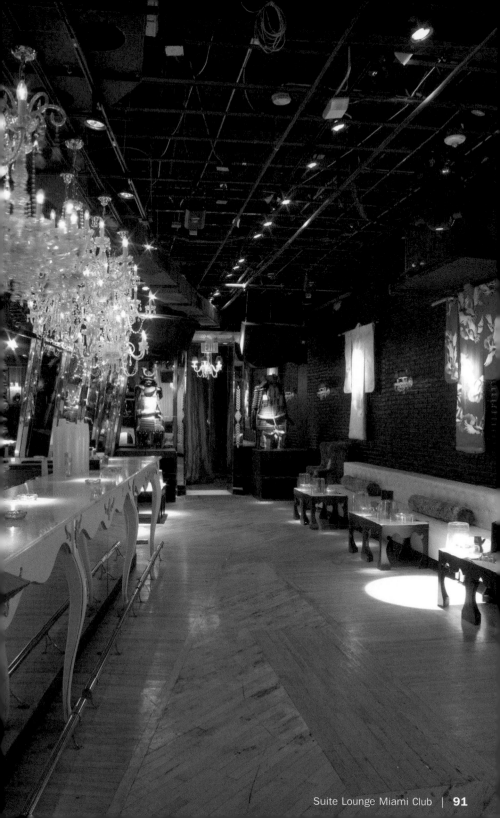

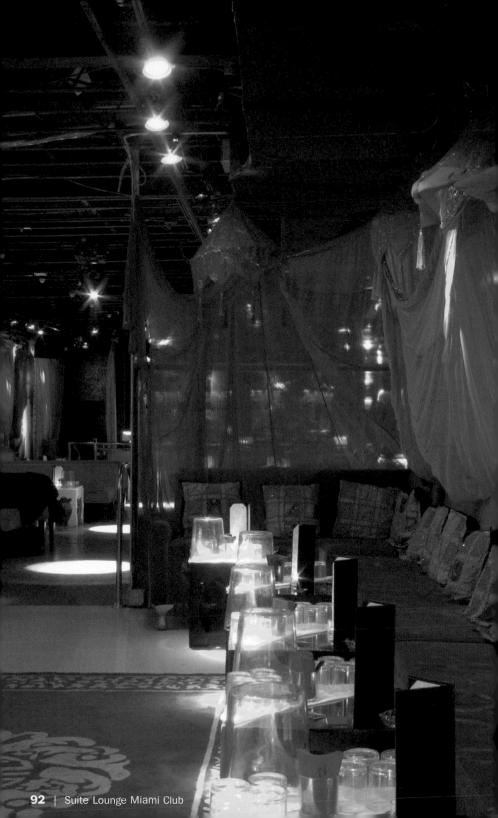

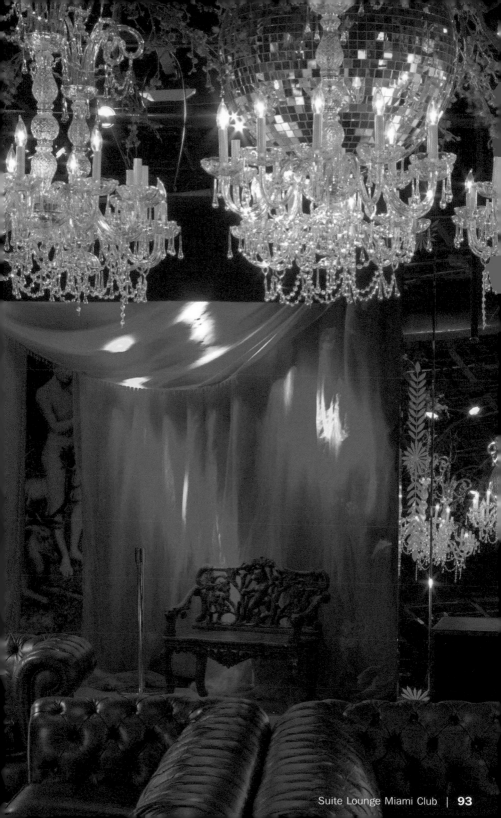

Tantra

Design: Stephane Dupoux

1445 Pennsylvania Avenue | Miami, FL 33139 | Miami Beach
Phone: +1 305 672 4765
www.tantrarestaurant.com
Opening hours: Every day 7 pm to 1 am, Lounge until 5 am
Best day: Mondays
Special features: Upscale restaurant with grass floors and starlit ceilings, belly danc-
ing to DJs, and serving aphrodisiac cuisine and Kama Sutra-inspired cocktails

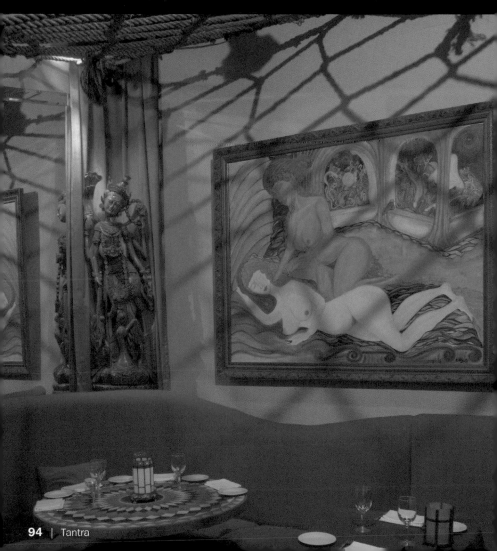

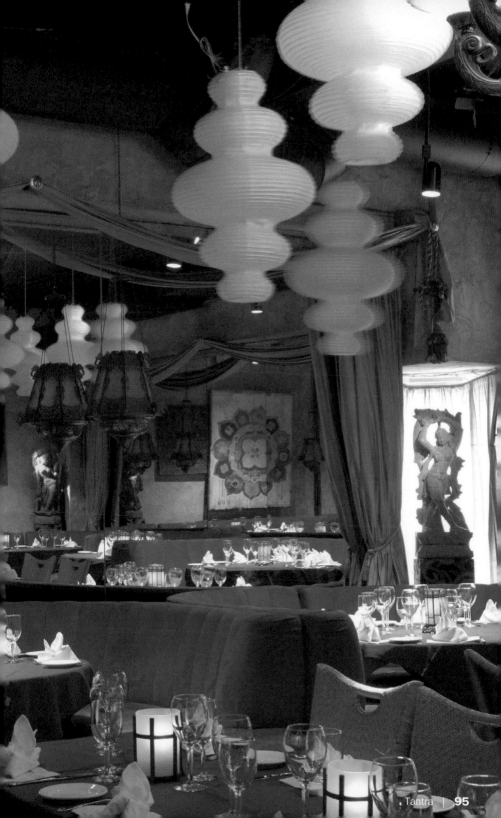

The Forge

Design: Al Malnik

432 41st Street | Miami, FL 33140 | Miami Beach
Phon -1 305 538 8533
www.theforge.com
Opening hours: Every day 6 pm to close
Best day: Wednesdays, Sundays
Special features: Different dining rooms each possess its own character, featuring high ceilings, ornate chandeliers, European artwork, and visited by who's who of Miami high society

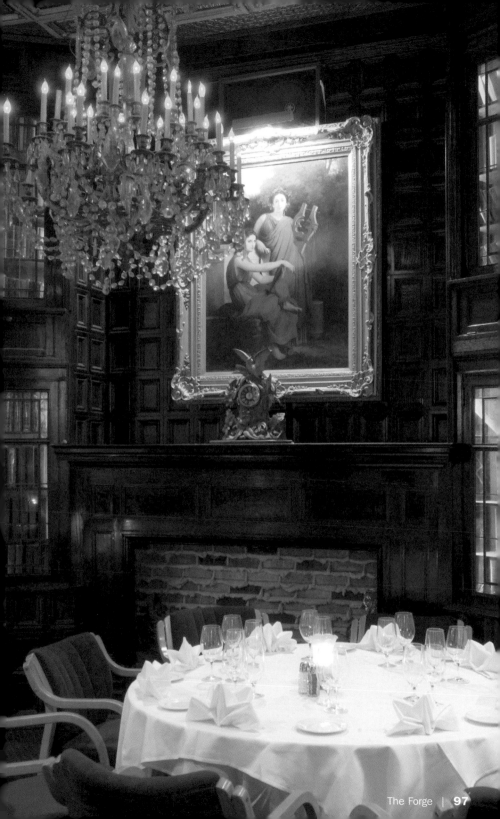

The Hotel of South Beach

Design: Todd Oldham

801 Collins Avenue | Miami, FL 33139 | Miami Beach
Phone: +1 305 531 2222
www.thehotelofsouthbeach.com
Special features: Boutique hotel designed like a vintage piece of couture by fashion designer Todd Oldham

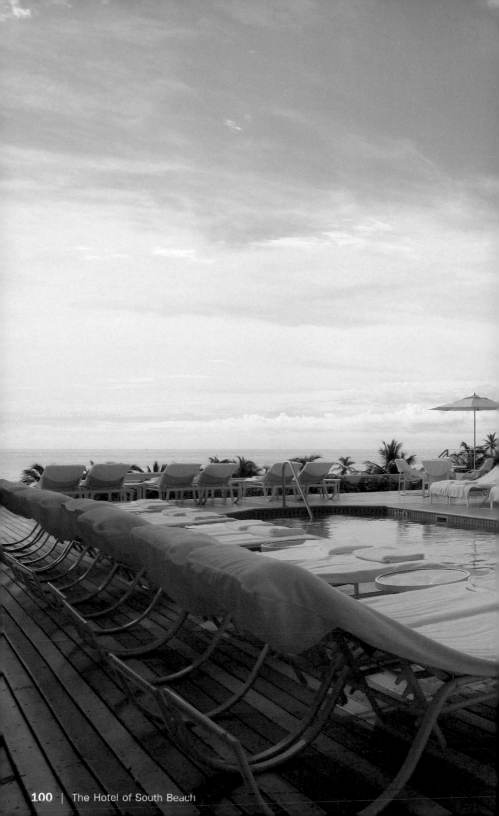

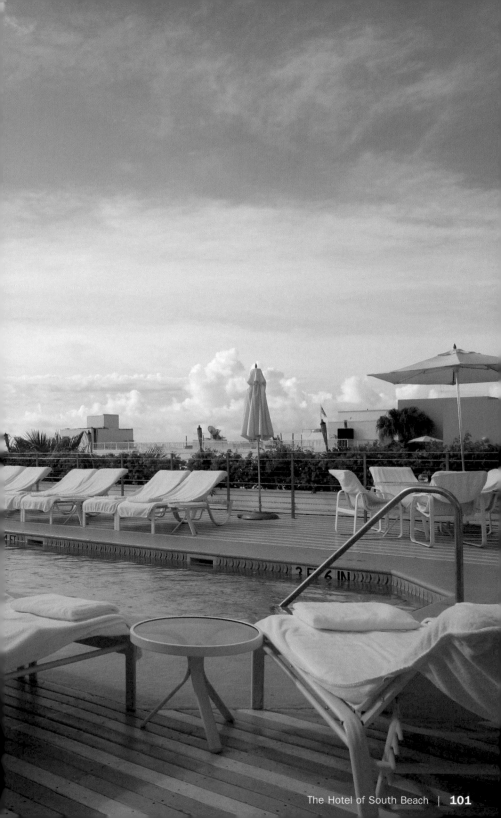

The Raleigh Hotel

Design: André Balazs Properties

1775 Collins Avenue | Miami, FL 33139 | Miami Beach
Phone: +1 305 534 6300
www.raleighhotel.com
Best day: Sundays
Special features: Most fabulous atmosphere to people watch by the hotel's infamous fleur-de-lis original 1940s pool

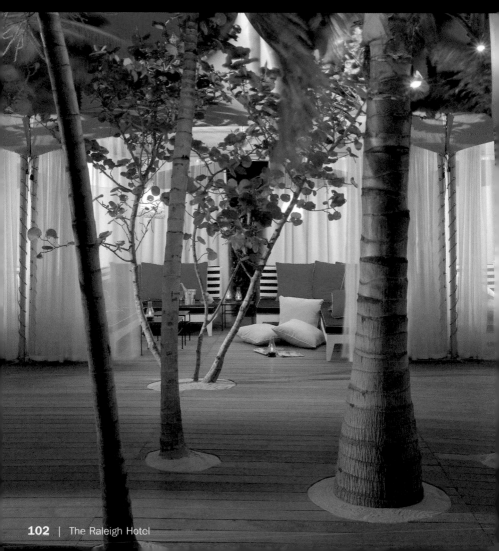

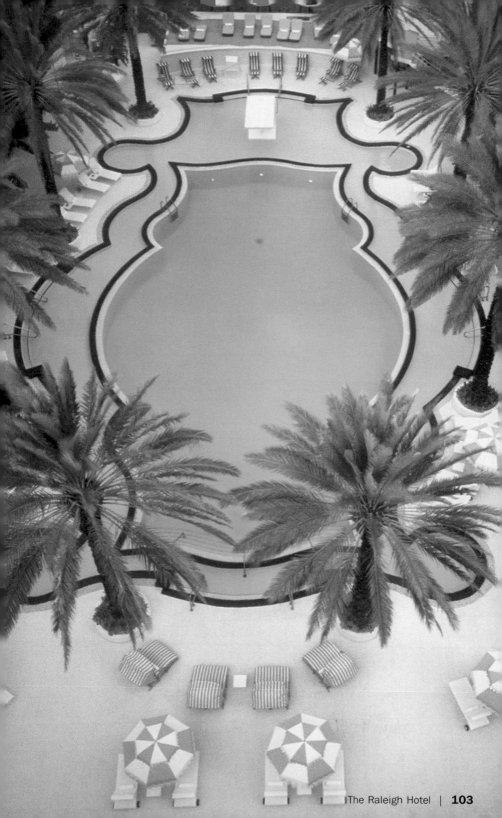

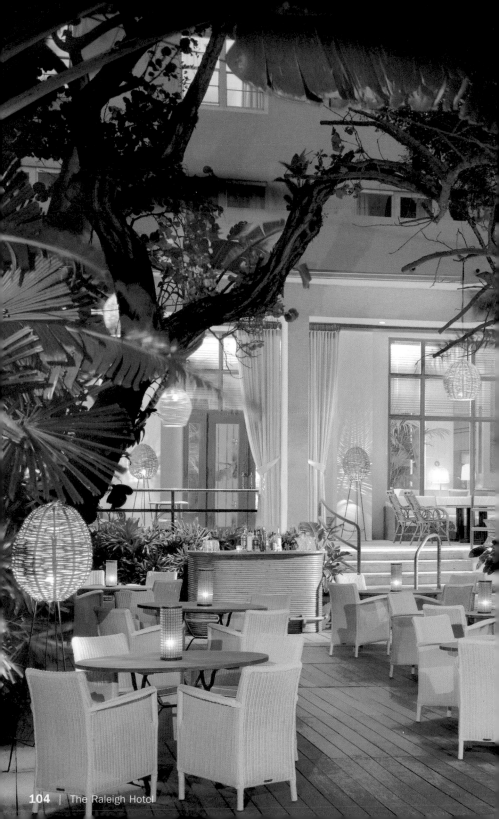

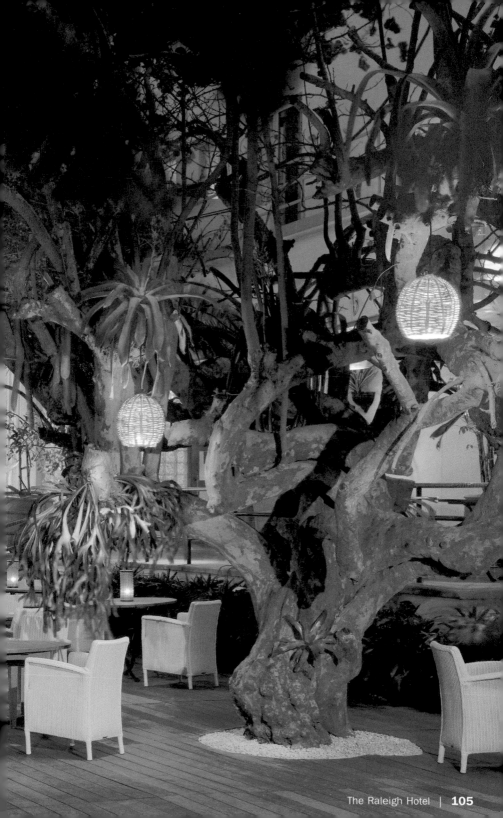

The Setai

Design: Jaya Pratomo Ibrahim of Jaya & Associates (interior),
Jean Michel Gathy (exterior)

2001 Collins Avenue | Miami, FL 33139 | Miami Beach
Phone: +1 305 520 6000
www.setai.com
Special features: Glamorous destination for the ultra hip and wealthy. Designed with
elegant Asian-styled features and surreal touches, including three exotic pools each
warmed to a slightly different temperature

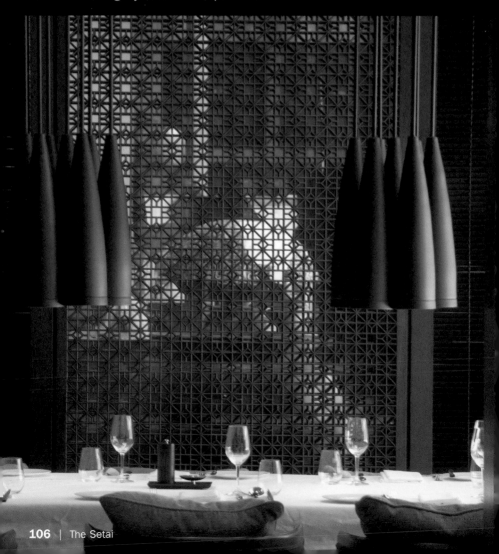

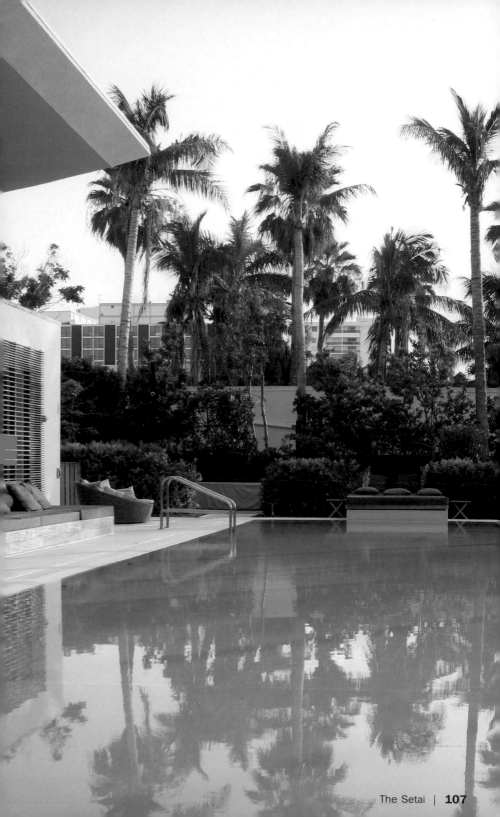

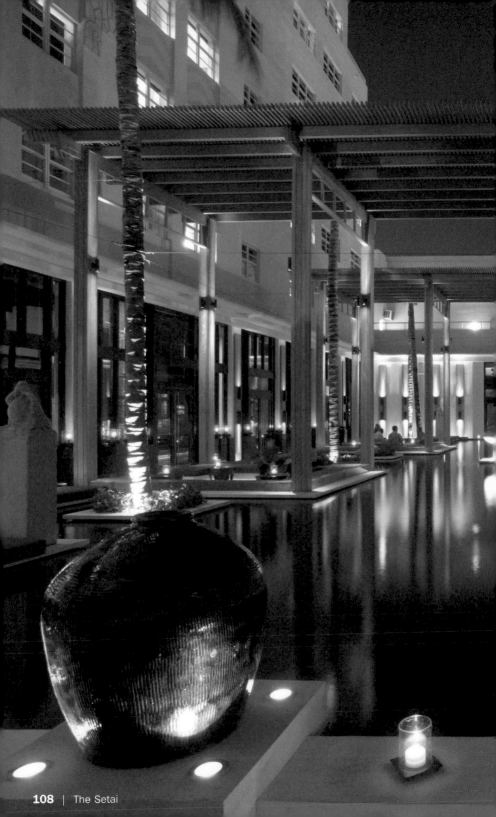

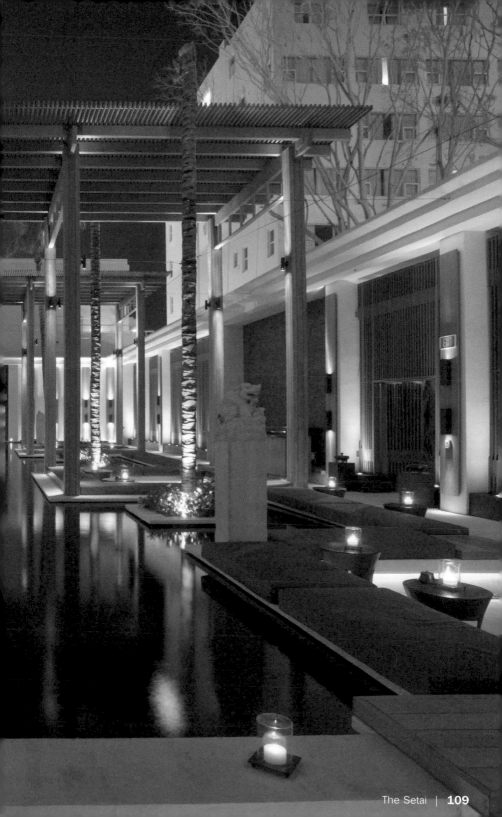

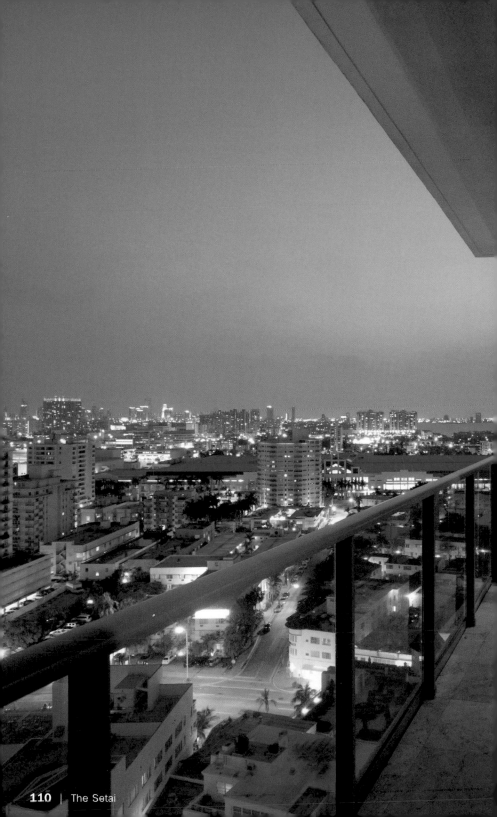

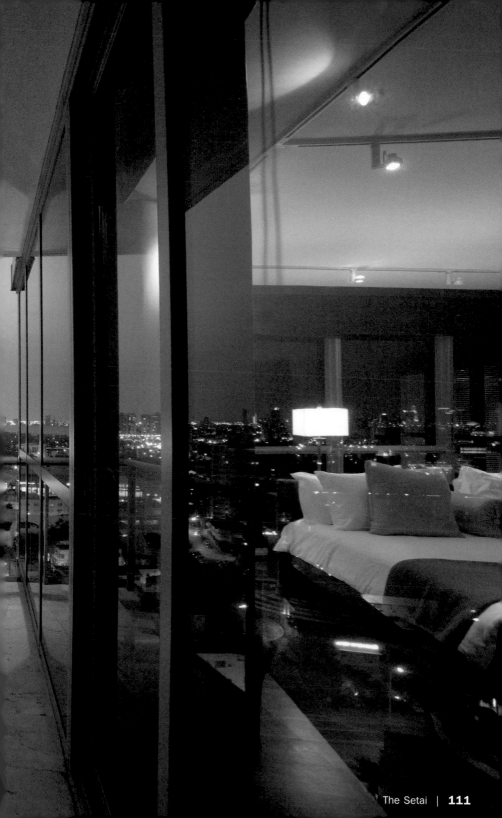

The Standard Miami

Design: Shawn Hausman and André Balazs Properties

40 Island Avenue | Miami, FL 33139 | Miami Beach
Phone: +1 305 673 1717
www.standardhotel.com
Special features: A unique spa hotel with communal water-based treatment areas for relaxation and hydrotherapy, including an infinity pool with sound piped underwater and a mud lounge

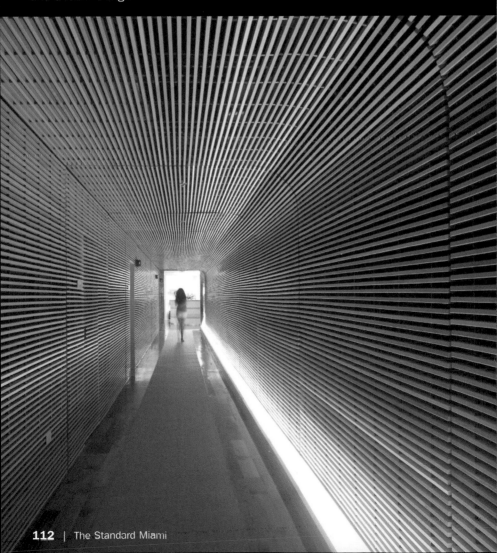

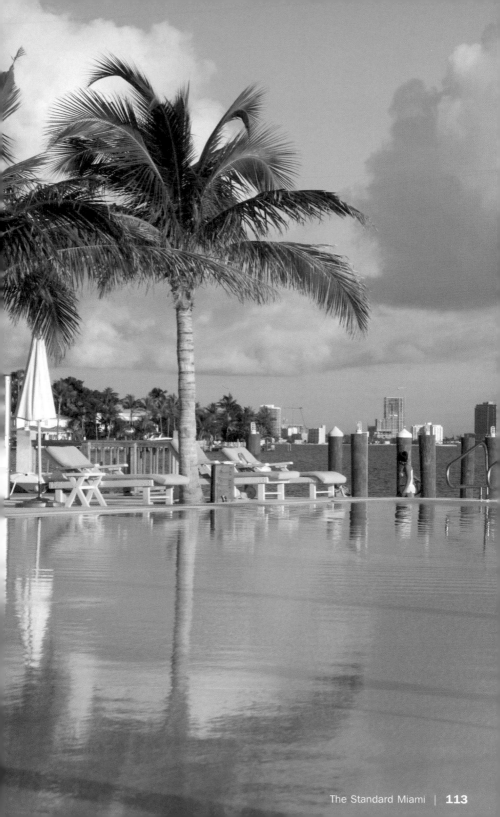

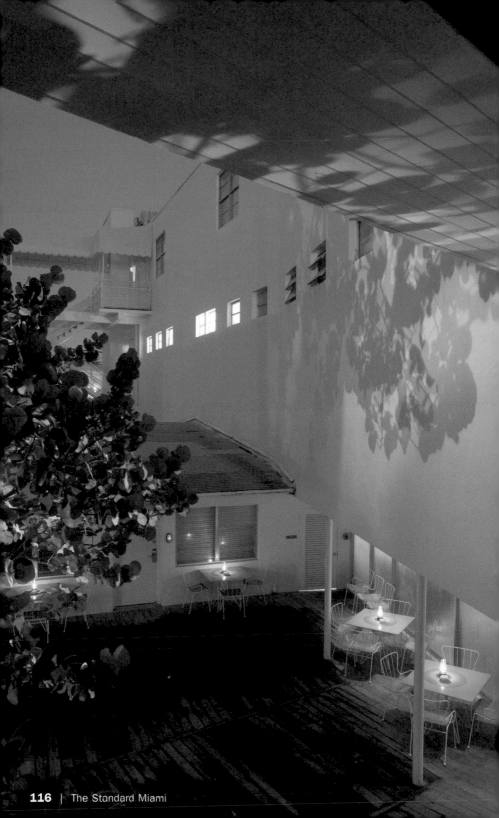

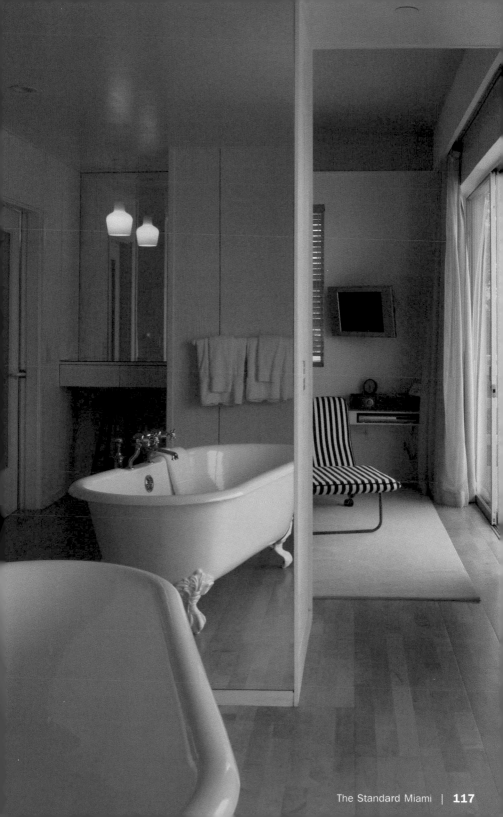

Townhouse

Design: India Mahdavi, imh interiors

150 20th Street | Miami, FL 33139 | Miami Beach
Phone: +1 305 534 3800
www.townhousehotel.com
Special features: Rooftop hangout on waterbeds, delicious Japanese dishes in Bond Street Lounge, affordable but hip design hotel rooms

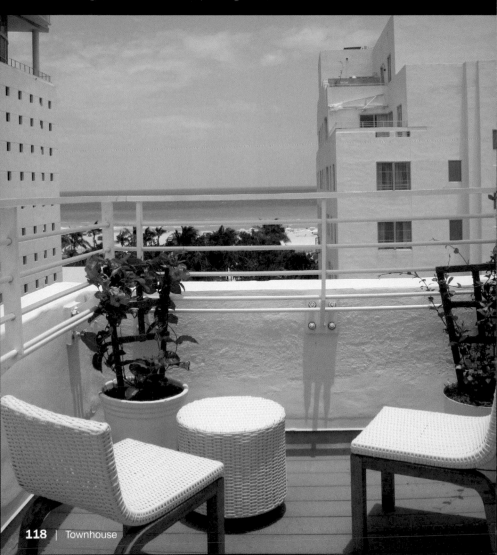

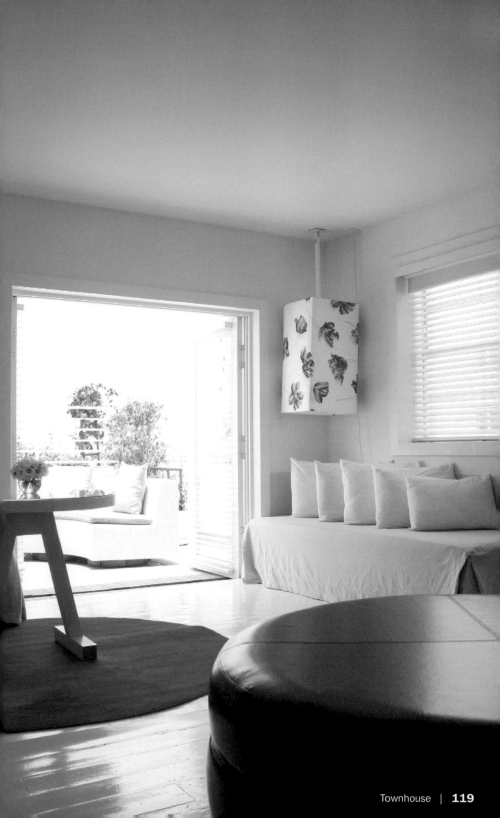

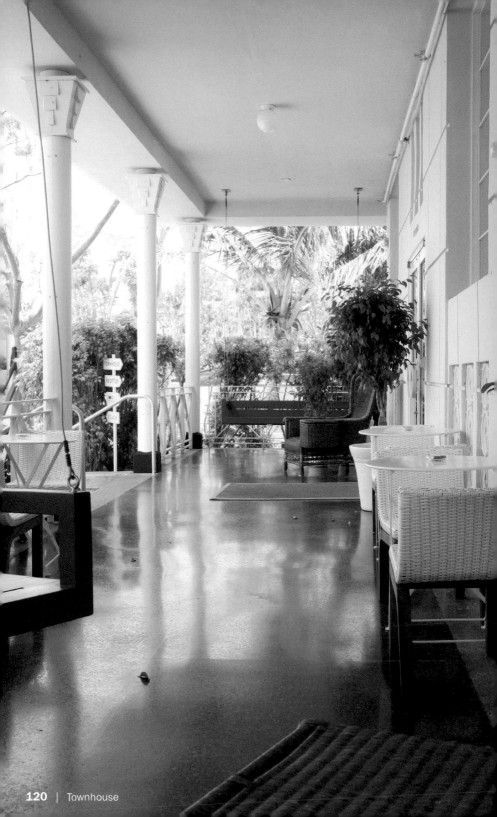

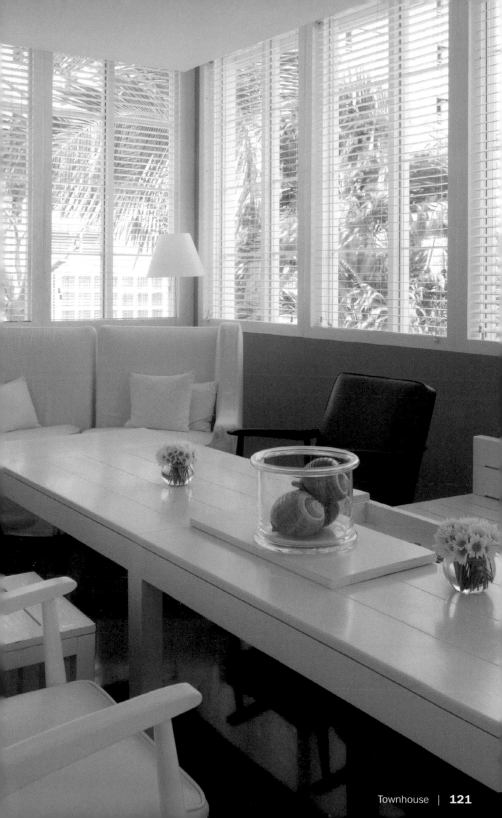

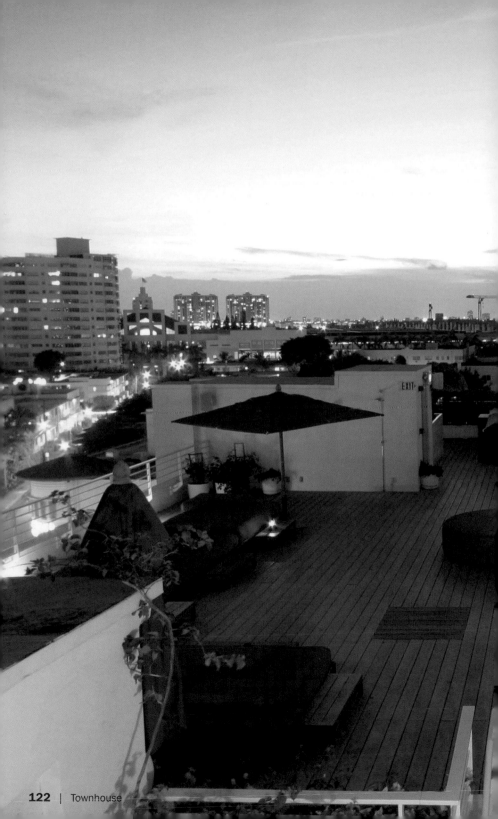

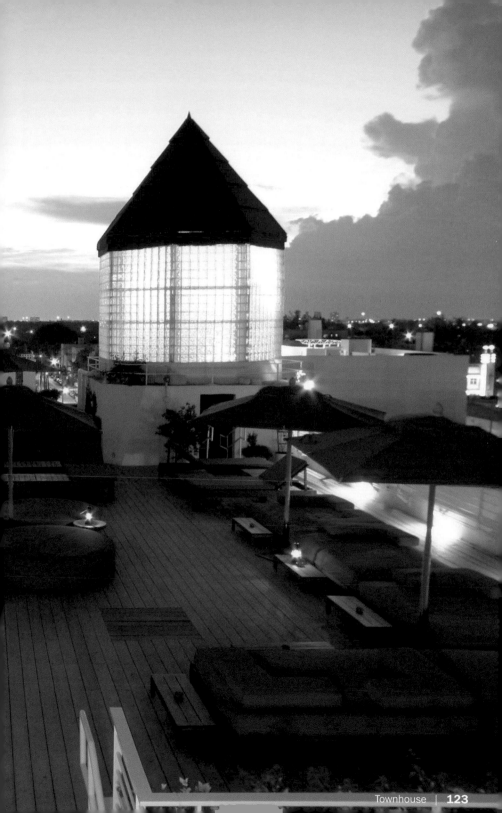

Vue

Design: Jacques Garcia

1142 Ocean Drive | Miami, FL 33139 | Miami Beach
Phone: +1 305 428 1234
www.hotelvictorsouthbeach.com
Opening hours: Mon–Sun 7 pm to open end
Special features: Upscale bistro is a magnet for South Beach's glitterati with an outdoor Ceviche bar

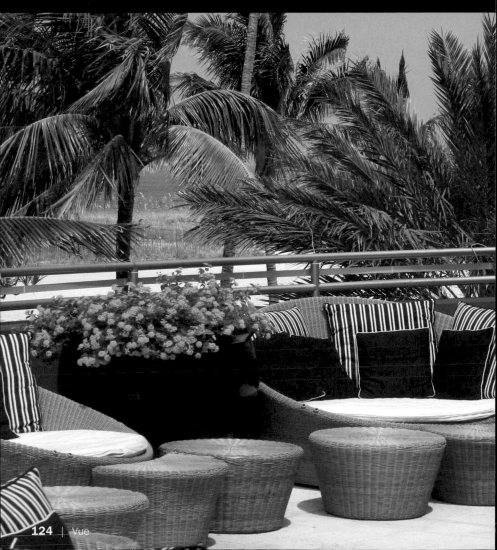

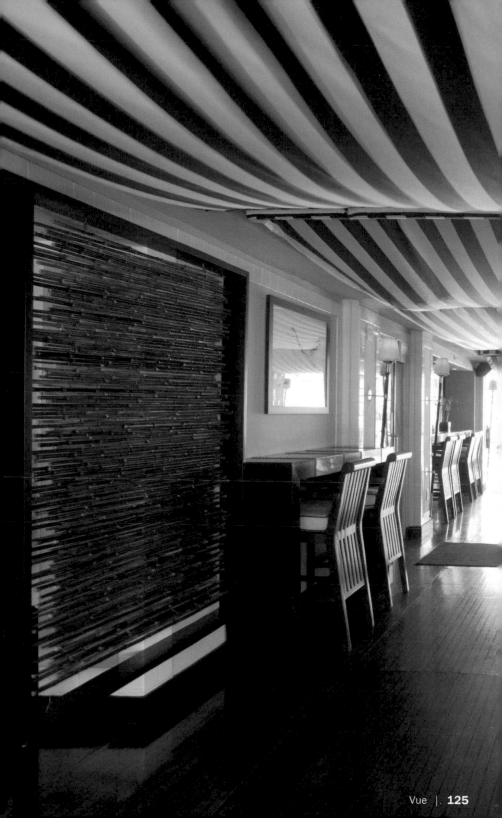

VIX

Design: Jacques Garcia

1143 Ocean Drive | Miami, FL 33139 | Miami Beach
Phone: +1 305 428 1234
www.hotelvictorsouthbeach.com
Opening hours: Tue–Sun 7 pm to open end
Special features: Dimly lit, cozy Mediterranean restaurant with massive jellyfish tank illuminated with fibre optics and hanging lamps resembling the stinging creatures

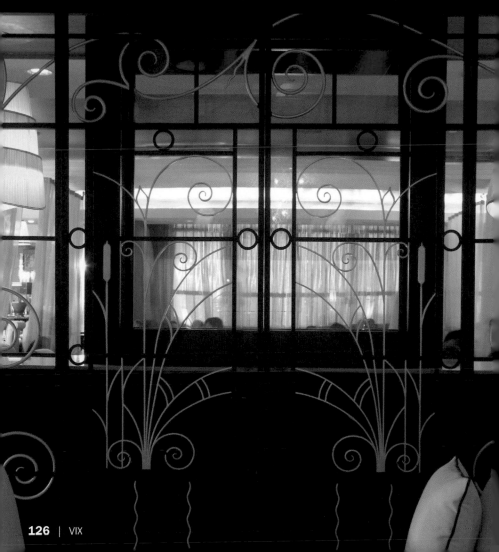

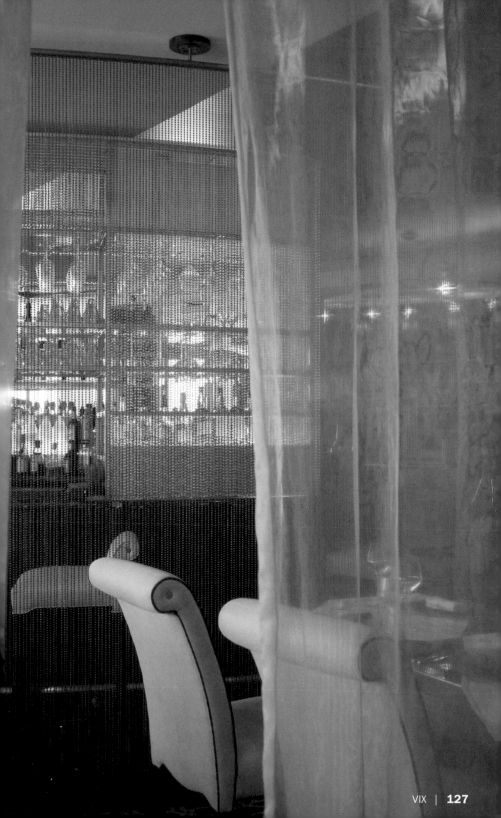

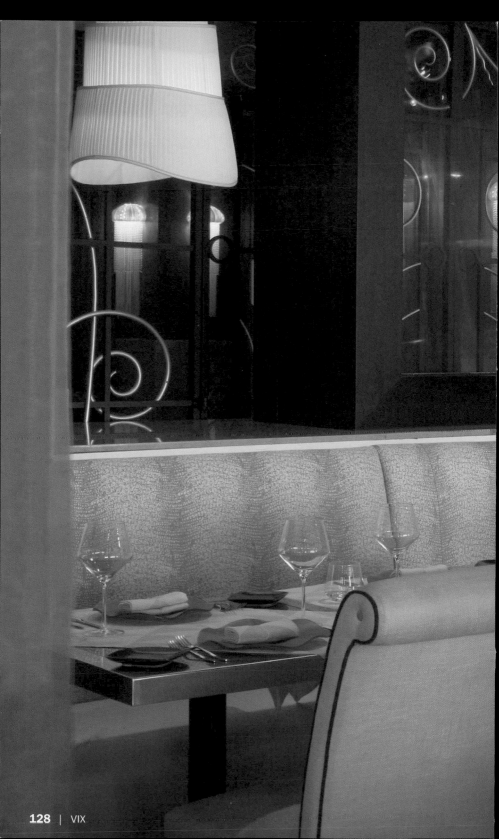

Wish

Design: Todd Oldham

801 Collins Avenue | Miami, FL 33139 | Miami Beach
Phone: +1 305 674 9474
www.wishrestaurant.com
Opening hours: Breakfast Mon–Sun 7 am to 11:30 am, lunch Mon–Sun 11:30 am
to 3 pm, dinner Tue–Sun 6 pm to 11 pm, Fri–Sat 6 pm to midnight
Special features: Inner garden-like dining experience with serene outdoor
umbrella-covered courtyard, excellent cuisine

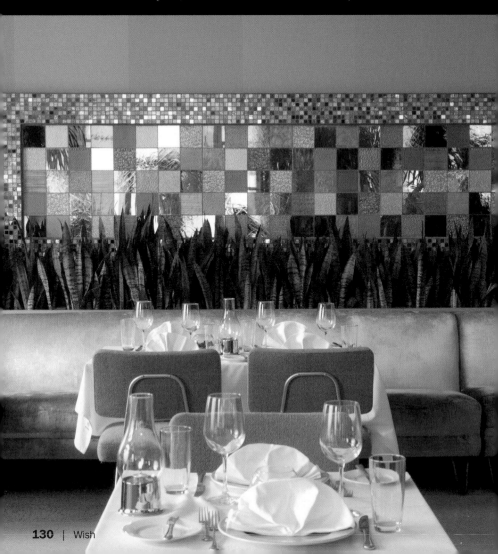

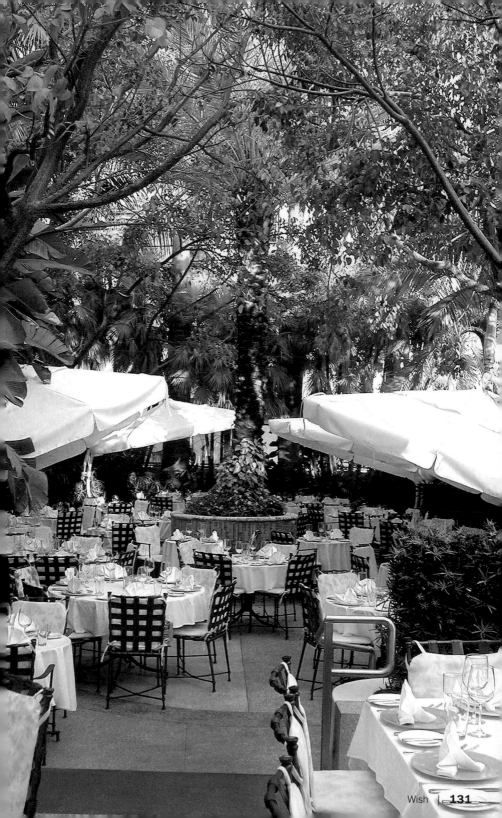

No.	Spot	Page
1	Bal Harbour Shops	10
2	Casa Casuarina	12
3	Casa Tua	18
4	Clinton South Beach	22
5	Hotel Astor	26
6	Hotel Victor	28
7	Johnny V	34
8	Lincoln Road	38
9	Mandarin Oriental Miami	44
10	Miami Design District	48
11	Mynt Lounge	54
12	Nikki Beach	58
13	Nobu	62
14	Ocean Drive	64
15	Opium Garden	68
16	Pearl	72
17	Prime 112	74
18	Privé	76
19	Ritz Carlton South Beach	78
20	Rok Miami	84
21	Snatch	86
22	Spire Bar & Lounge	88
23	Suite Lounge Miami Club	90
24	Tantra	94
25	The Forge	96
26	The Hotel of South Beach	98
27	The Raleigh Hotel	102
28	The Setai	106
29	The Standard Miami	112
30	Townhouse	118
31	Vue	124
32	VIX	126
33	Wish	130

Lincoln Road

Park Avenue

Washington Avenue

Drexel Avenue

Pennsylvania Avenue

Euclid Avenue

Meridian Avenue

Jefferson Avenue

Michigan Avenue

Lenox Avenue

Bayshore Municipal Golf Course

Sunset Islands

Lincoln Road

134

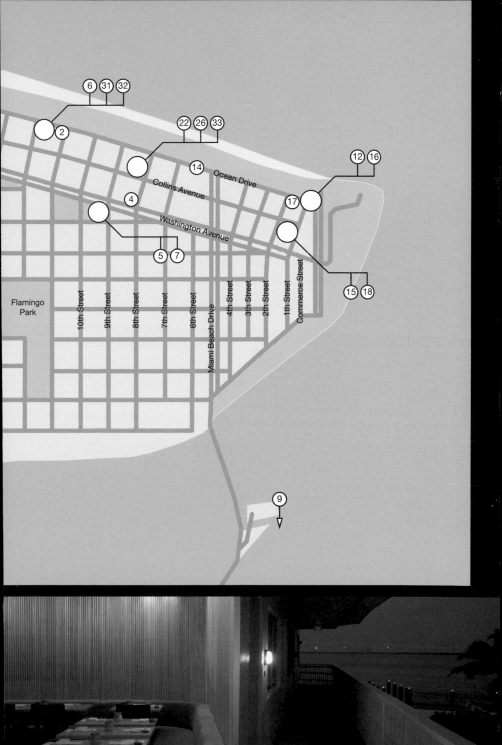

Flamingo
Park

6 31 32

2

22 26 33

14

Ocean Drive

Collins Avenue

4

12 16

17

Washington Avenue

5 7

15 18

10th Street
9th Street
8th Street
7th Street
6th Street
Miami Beach Drive
4th Street
3th Street
2th Street
1th Street
Commerce Street

9

135

Cool Restaurants

Amsterdam	**Madrid**
ISBN 3-8238-4588-8	ISBN 3-8327-9029-2
Barcelona	**Mallorca/Ibiza**
ISBN 3-8238-4586-1	ISBN 3-8327-9113-2
Berlin	**Miami**
ISBN 3-8238-4585-3	ISBN 3-8327-9066-7
Brussels (*)	**Milan**
ISBN 3-8327-9065-9	ISBN 3-8238-4587-X
Cape Town	**Moscow**
ISBN 3-8327-9103-5	ISBN 3-8327-9147-7
Chicago	**Munich**
ISBN 3-8327-9018-7	ISBN 3-8327-9019-5
Cologne	**New York** 2nd edition
ISBN 3-8327-9117-5	ISBN 3-8327-9130-2
Copenhagen	**Paris** 2nd edition
ISBN 3-8327-9146-9	ISBN 3-8327-9129-9
Côte d'Azur	**Prague**
ISBN 3-8327-9040-3	ISBN 3-8327-9068-3
Dubai	**Rome**
ISBN 3-8327-9149-3	ISBN 3-8327-9028-4
Frankfurt	**San Francisco**
ISBN 3-8327-9118-3	ISBN 3-8327-9067-5
Hamburg	**Shanghai**
ISBN 3-8238-4599-3	ISBN 3-8327-9050-0
Hong Kong	**Sydney**
ISBN 3-8327-9111-6	ISBN 3-8327-9027-6
Istanbul	**Tokyo**
ISBN 3-8327-9115-9	ISBN 3-8238-4590-X
Las Vegas	**Toscana**
ISBN 3-8327-9116-7	ISBN 3-8327-9102-7
London 2nd edition	**Vienna**
ISBN 3-8327-9131-0	ISBN 3-8327-9020-9
Los Angeles	**Zurich**
ISBN 3-8238-4589-6	ISBN 3-8327-9069-1

teNeues

COOL SHOPS

BARCELONA
ISBN 3-8327-9073-X

BERLIN
ISBN 3-8327-9070-5

HAMBURG
ISBN 3-8327-9120-5

HONG KONG
ISBN 3-8327-9121-3

LONDON
ISBN 3-8327-9038-1

LOS ANGELES
ISBN 3-8327-9071-3

MILAN
ISBN 3-8327-9022-5

MUNICH
ISBN 3-8327-9072-1

NEW YORK
ISBN 3-8327-9021-7

PARIS
ISBN 3-8327-9037-3

TOKYO
ISBN 3-8238-9122-1

COOL SPOTS

LAS VEGAS
ISBN 3-8327-9152-3

MALLORCA/IBIZA
ISBN 3-8327-9123-X

MIAMI/SOUTH BEACH
ISBN 3-8327-9153-1

Size: 14 x 21.5 cm
5 1/2 x 8 1/2 in.
136 pp, Flexicover
c. 130 color photographs
Text in English, German, Fre
Spanish, Italian or (*) Dutch